the photographer's guide to Oregon Coast

Where to Find Perfect Shots and How to Take Them

David Middleton and Rod Barbee

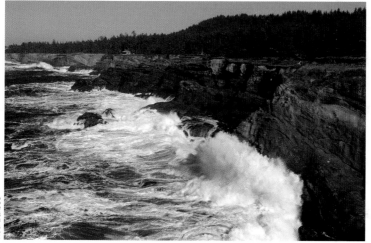

Rod Barbee

THE COUNTRYMAN PRESS
WOODSTOCK, VERMONT

ISBN 0-88150-534-X

Cover and interior design by Susan Livingston
Front cover photograph by Rod Barbee
Interior photographs by Rod Barbee and David Middleton
Photographs on pages 15, 35, and 53 by Scott Bourne
Maps by Paul Woodward, © The Countryman Press

Published by The Countryman Press, P.O. Box 748, Woodstock, Vermont 05091
Distributed by W. W. Norton & Company, Inc., 500 Fifth Avenue, New York, NY 10110

Printed in Spain at Artes Graficas Toledo

10 9 8 7 6 5 4 3 2 1

Frontispiece: Crescent Beach and Cannon Beach from Ecola State Park
Opposite: Fishing boats at dusk, Coos Bay

To all my students
—D.M.

Dedicated to my wife and best friend, Tracy Rowley,
for believing in me and being there for me.
—R.B.

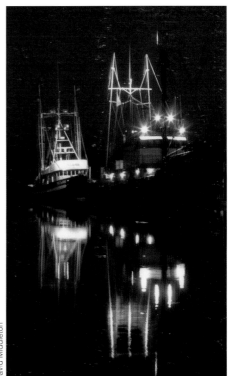

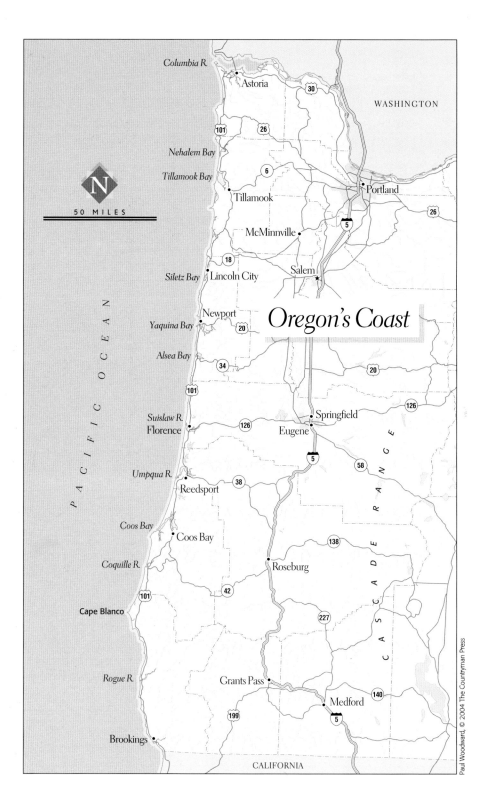

Columbia R.

Astoria

30

WASHINGTON

101

26

Nehalem Bay

Tillamook Bay

6

Tillamook

Portland

26

5

McMinnville

N

50 MILES

18

Siletz Bay • Lincoln City

Salem

Oregon's Coast

PACIFIC OCEAN

Newport

20

Yaquina Bay

Alsea Bay

34

20

101

126

Suislaw R.

Springfield

126

Florence

Eugene

R A N G E

5

58

Umpqua R.

38

Reedsport

C A S C A D E

Coos Bay

• Coos Bay

138

Coquille R.

Roseburg

42

101

Cape Blanco

227

Rogue R.

Grants Pass

140

Medford

199

5

Brookings

CALIFORNIA

Contents

Introduction

The Oregon coast is part California, part Washington. Its southern reaches mark the northernmost limit of the great redwood empire that covers the North Californian coast. And its northern reaches share the waters of the mighty Columbia River—the great river of the Northwest—with Washington. The entire coast, publicly available to all, is characteristically Oregon: stunning at every turn, friendly in every town, and rewarding at every try.

The coast is a photographer's playground. Are you a wildlife photographer? Here are puffins and whales, seals and elk as well as the ubiquitous gulls, cormorants, and sandpipers. Are you a landscape photographer? Here are rocky headlands, long and sweeping beaches, quiet lakes, towering dunes, and ancient forests. Are you a travel photographer? Picturesque harbors full of all shapes and sizes of boats and piles of colorful fishing gear will keep you happy. Do you like to photograph people? You'll find more characters and weather-worn old salts than you can photograph in two lifetimes.

This is the magic of the Oregon coast for photographers: Any one spot always has something for everyone. Now, you may have to hunt around a bit to find it, or you may have to be patient until just the right something comes along, but with time and a bit of luck you should be able to get some nice pictures.

If you want to get *great* pictures, you'll need time, a bit of luck, *and* this book to lead you to the very best locations. They're all here. My secret spots are now your secret spots, so take good care of them. If you feel compelled to share them with other photographers, have them buy this book, instead. This will benefit me and give you a head start to the next location.

So grab a map, find a comfortable place to sit, and start planning your next trip to the Oregon coast. If you happen to find any additional secret spots, be sure to share them with me. I won't tell anyone—until the next edition of this book comes out. Happy hunting!

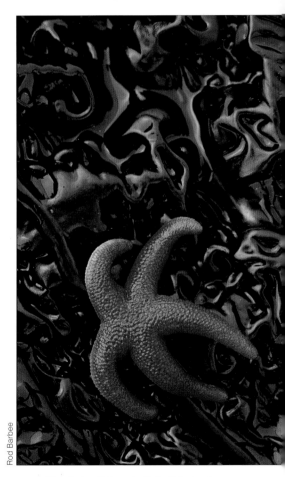

Blood starfish on kelp in tide pool

Using This Book

This book evolved out of the incessant questioning of my students about where the best places are to photograph along the Oregon coast. Believing that I'd actually tell them the truth, they would hand me maps and blank sheets of paper, and I would describe areas and highlight roads for them to explore. But it was never that easy. There were always more places to suggest that they go—the Oregon coast is a rich area for photographers.

This book is my final answer to their questions. It includes all of my favorite places to photograph. I didn't leave out any extra-secret sites (at least none that you would know about), and I have included all the best-known locations on the Oregon coast. I have tried to give special attention to well-known family vacation spots because those are the places most photographers with a spare hour or two to photograph are going to find themselves.

Along with a description of each place, I have included information on when the best times might be to visit. This is done with a bit of trepidation because year to year, peak times can vary so much. But because the seasons are so blurred, it will be peak *somewhere* whenever you visit the coast.

As to what to do once you get to the location, I've included some suggestions about what I generally do at each site. You are welcome to do the same, or ignore them altogether. I've also given you the things you *don't* want to do at the site. Some are physical things to be careful about, and some are photographic things to watch out for and avoid.

In the back of the book is a list of additional "Favorites," an inventory of the best harbors, beaches, lighthouses, and sunrise and sunset locations to photograph as well as the best tide-pooling locations and nonphotography places to visit. This is all very subjective, of course, and strictly my opinion.

Remember that the coast is a tidal environment, so a scene that looks dreadful at high tide may look wonderful at low tide or vice versa. In other words, for every coastal location included in this book you'll get many different looks, depending on the level of the tide. Your first Pro Tip: Harbors generally look better at high tide, tidal creeks look better at midtide, and tide pools look best at low tide.

Most importantly, use this book to explore the Oregon coast and enjoy yourself in the process. If you drive slowly and walk every beach you see, you may never leave. Grab a map, pick a location, and have a wonderful time. You can thank me later.

How I Photograph the Oregon Coast

Whenever I photograph, I evaluate four parameters: light, subject, background, and conditions. If all four are great, you have the potential for a great shot. If—more typically—only a couple of them are great, you'll have to work a bit harder to get a nice image, and your photographic possibilities will be much reduced.

But having less than the ideal situation doesn't mean you shouldn't go out and shoot; it just means you'll have to think about what you're doing. Yes, I know: Thinking is the last thing that photographers want to do. But it really helps. If you shoot everything on "program" or "automatic" mode, remember: autofocus, autoexposure, oughtaknowbetter.

Let's examine coastal Oregon's light, subjects, backgrounds, and conditions and see how I can help you get better photographs. By the way, photography is photography, whether you use a drugstore point-and-shoot, an expensive Nikon SLR, or a newfangled digital camera. It's all the process of capturing light in a pleasing way.

This is how I photograph the Oregon coast.

Light

Light is the key ingredient for a good photograph. Photography is, after all, the process of capturing light on film. We may think we're out photographing landscapes or barns or children or flowers or moose, but we're actually out capturing light. If you think about the quality of the light as much as you think about the quality of your subject, your pictures will improve dramatically. If you have great light and a mediocre subject, you can still end up with a great photograph, but if you have a great subject and mediocre light, you will only end up with a mediocre photograph. A great shot requires great light. Dull light equals a dull photograph. Write that down.

Most of the time, I photograph on cloudy days and work in the office on sunny days. This is because film doesn't like strong light very much; there's just too much of it for film to completely capture. Either the highlights are washed out white, or the shadows are blocked up black. The end result is an extremely high-contrast picture. Slide film holds the narrowest range of contrast, digital capture is a bit better, and print film is best at holding contrast, but none will faithfully render all the light that's present on a sunny day.

I do occasionally go out and shoot on a sunny day. Blue skies are great for mountaintop photography, autumn color, and to set off a pretty white church. Blue skies are also great for reflections, and I'll often head for water when the weather turns

Both: Rod Barbee

Bad light

sunny. If you know it's going to be a sunny day, go out very early and shoot the first few hours after sunrise. The light at this time is softer and warmer, and everything looks great in this light. The same is true for later-afternoon to sunset light.

If you are photographing any buildings with interior lights on or any cityscapes or harborscapes, do this at twilight—the 30 to 40 minutes before sunrise and after sunset. At twilight there's just enough light to see the buildings and the scene around them, and no matter the weather, the background will always be a beautiful dark lavender-blue. Plus interior lights add a nice warm punctuation to an image.

Cloudy days, though, are my favorite. When it's cloudy the range of contrast is very small, so all the subtle colors that you see will be captured beautifully by your camera. Not all cloudy days are created equal, however. Sometimes it can be heavily cloudy while other times it can be thinly cloudy. Given my choice, I like thin clouds. On partly sunny/partly cloudy days when the light is varying between full sunlight, heavy cloudy light, and thin cloudy light, I wait until the sun is just behind the edge of a cloud to snap my picture. This is the thin light that's rendered best on film.

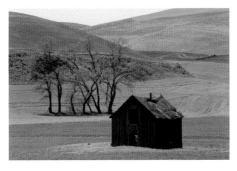

Good light

Cloudy days also include rainy days. In fact, my all-time-favorite light is a fine misty rain. Before you start shaking your head, go out and try photographing in this light—you will be wonderfully surprised. You'll have both long exposures and long times to yourself, but it will be worth it—trust me. Beware, though: Some older-generation digital cameras add visual noise to the image with exposures longer than 10 seconds.

Subject

Everything you photograph has a peak time. It may be a barn after a fresh coat of paint, a wildflower fully in bloom, or an autumn hillside fully ablaze, but everything has a day, a week, a couple of weeks when it's at its best. Ideally, this is when to photograph it. But peak times are sometimes hard to find and often last for a frustratingly short period.

What if you've missed the peak time where you are? If you're too early in the season, go farther south or lower in elevation. You can also try looking for your subject on seasonally earlier, south-facing hillsides. If you're too late seasonally, go farther north or higher in elevation. You can also try looking for your subject on seasonally later, north-facing hillsides. The time difference seasonally between the eastern, more northerly Oregon coast and the western, more southerly Oregon coast and between sea level and the mountaintops can be two weeks.

The other problem with trying to predict peak times is that they are utterly unpredictable. For the years that I have been actively photographing along the coast, the flowering times for my favorite spring wildflowers and for peak fall color have

Rhododendrons in spring

varied by as much as three weeks. My advice is to stay flexible with your intentions, and you'll always find something wonderful to photograph.

Background

Background is usually overlooked despite it being essential to overall image quality. We get so intent on our subject that we forget to consider what's behind it—yet the background will often make or break a picture. It doesn't matter how magnificent your subject is, if the background is terrible, the picture will be terrible. I often choose my subject based on the quality of the background, and the angle of the shot is always based on the background. If I'm photographing wildlife, the background determines where I'll set up and how I'll approach the animal.

Nothing destroys a pretty portrait of an animal, person, flower, or tree like something that appears to be coming out of the subject's head. The usual culprit is a bright stick or piece of grass in the background that intersects the subject and on film merges with it. In the three-dimensional world in which the picture was taken, the bright stick is well behind the flower, but in the two-dimensional world of your film that stick is piercing your pretty flower, that telephone pole is coming out of Aunt Edna's head, and those maple branches are deer antlers.

Diligently look for bright objects in the background. If something in your picture is brighter than your subject, your eye will go to the brightest part of the image; if that isn't your subject, then it becomes a distraction. And even one distraction is too many.

How do you know what your background will look like before you see the final image? On more sophisticated cameras, a depth-of-field preview button allows you to see what the focus of the final image will look like before you take the picture. When you push the button, the lens closes down to the f-stop you have selected, and you get to preview your image and see how much of your image will or will not be in focus.

Bad background

Good background

On the Oregon coast the biggest background problems are bright reflective metal roofs, white boat hulls, roads, and telephone lines. Telephone lines can be very sneaky in Oregon—especially when they sneak through the forest or span a harbor—so always be alert for them. If the distraction you detect can't be judiciously or without harm removed (*never* break a branch or pull up a plant or harm anything just because it isn't where you want it to be; your picture, my picture, anybody's picture is really not that important), try to darken the distracting background with the shadow of your camera bag, your companion, or even your own shadow. Use the self-timer on your camera, and then move around and cast your shadow behind your subject. I also carry a short length of twine in my camera bag to tie back offending branches without breaking them.

Conditions

Conditions are (for the most part) the weather you find yourself in when out photographing. Nothing is more frustrating than setting up a shot and having the wind kick up or the light change right before you're ready to shoot.

Wind forces you to be patient. I have gone through a lot of film doing long exposures when the wind decides to blow halfway through my exposure. Nothing you can do but try again. On windy days I usually head for streams and concentrate on the moving water and the rocks

When it's raining, head into the forest. It won't be raining as hard in there, and the forest will never look better. I don't use any elaborate rain covers when I'm out photographing in the rain. My camera is about as tolerant of water as I am, so

when I'm miserable, my camera is miserable. I don't walk around with it exposed to the rain, but when it's on my tripod, I don't worry about the little moisture it's collecting. I keep a towel in my camera bag and one in my car to dry it off eventually, but I don't do any other extraordinary things.

My rule that applies to rain also applies to cold-weather photography: When I'm too cold to photograph, my camera is, as well. If it's very cold, I carry extra batteries in my pocket to keep them warm, but that's the only precaution I take. Be careful when pushing your tripod into snow— the snow will force the legs even farther apart and may cause them to snap off. Oregon's streams are very photogenic in winter, but beware of ice that's often hiding under a layer of snow.

If I'm out and it turns sunny unexpectedly, I usually look for reflections to photograph. Go to a colorful spot like a harbor or a market or a lake, and play with the blue sky and the mirror images you find. Blue sky is also a great time to take looking-straight-up photographs. Lie on your back in a forest, and shoot the treetops. Or lie in a meadow, and shoot up at the flowers—or even lie beneath a church steeple, and shoot it against the blue sky. Don't lie there too long, though; the parishioners might start a service for you.

Another Oregon coast condition you can do very little about is the thriving insect life—particularly the infamous black flies and the equally hideous mosquitoes. (Yes, I know black flies and mosquitoes are important parts of Oregon's natural history. I'd just prefer that they weren't part of *my* natural history.) Beginning in May and continuing through June and in some high places even into July, black flies

and mosquitoes can become so distracting that they'll suck out all your creative juices—not to mention your blood.

The best way to tolerate them is to *learn* to tolerate them. The various salves, sprays, and liquids sold virtually everywhere are only partially effective at best. (And be careful to not get any of this goop on your gear because it can eat plastic.) Black flies are thickest near moving water, and mosquitoes are thickest near still water—which about covers the entire state. That being said, I have seldom found these bugs to be so bad that they prevent me from taking a picture. They can be bad at one location and absent at the next one you go to. Just in case, wear long sleeves and long pants, and a hat. Add an aura of patience, and you'll be just fine.

One final note on a condition that's particular to Oregon and not to a lot of other places: the tide. There are actually many Oregon coasts: the coast at low tide, the coast at high tide, the coast at midtide, and the coast at all the tide levels in between—not to mention the coast at extremely high tide and extremely low tide. Each of these will present a different landscape. What you may not like at low tide may really excite you at high tide and vice versa. And at times of an exceptionally low tide, things may be visible that aren't normally, or there may be access to places that are normally inaccessible. So don't write off a location just because you didn't like it the only time you went there. At a different tide you'll likely be surprised at how different it is.

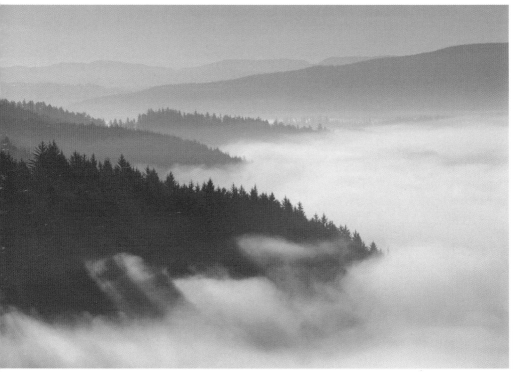

Rod Barbee

The fog rolls in and creates an otherworldly scene

In general, harbors look best on a rising tide from mid to high because there's usually lots of junk on the shallow harbor bottom that gets exposed at low tide that isn't very photogenic. On the other hand the coast at low tide will have lots of rocks and ledges exposed, which can be nice for foreground interest. Just be careful of the crusty old car that's out where it doesn't belong.

Oregon Coast Photo Specialties

Whale Watching

Several species of whale inhabit the Pacific Ocean off the Oregon coast, including blue, humpback, and killer whales, but the one most often seen is the gray whale. The best times to see whales are during the winter and spring migrations, though "resident" whales can be spotted almost any time of the year.

Many places along the coast are good for whale watching. The higher the vantage point the better—this means capes and headlands. The following is a short list of good places, listed north to south, to get you started:

Ecola State Park
Cape Falcon
Cape Meares, Cape Lookout, Cape Kiwanda
Cape Foulweather and the Otter Crest Loop
Boiler Bay State Wayside
Depoe Bay
Yaquina Head Natural Area
Cape Perpetua
Sea Lion Caves
Heceta Head
Umpqua Light

Scott Bourne

Beluga whale's eye

Shore Acres State Park, Cape Arago State Park
Coquille Point, Face Rock Wayside
Port Orford Head
Cape Blanco State Park
Boardman State Park
Harris Beach State Park

Photographically speaking, you won't get any good pictures of whales from shore. That's not to say you shouldn't even bother looking. Get out your binoculars, and try to get a peek at these amazing animals. After all, one reason we're out photographing is to get closer to nature. So what if you can't actually photograph something? The point is to be amazed at actually seeing it.

That said, if you want to try photographing whales, any number of charter companies along the coast will be happy to take you out and get you closer. Depoe Bay, the self-proclaimed whale-watching capital, has several excellent charter companies. According to one charter operator I spoke with, summer brings whales

closer to shore for feeding, while in spring migrating gray whales can be found a little farther out.

For a lot more information on whale watching, go to www.whalespoken.org, or call the Oregon Parks and Recreation Department at 541-563-2002.

Tide Pool Photography

Plenty of great places for tide pool photography can be found along the coast. Here are some general tips to help you get the best pictures.

Close-up lenses like a 100mm or 200mm macro work well for tide pool

Sea stars

David Middleton

photography. Zoom lenses in the 100mm to 300mm range with screw-on diopters (sometimes called close-up lenses or close-up filters) are also a very good choice.

Use a polarizer. Areas around water have lots of glare; a polarizer will help cut through it.

Have a black umbrella or a dark jacket handy to block the sky. This will help with contrast problems caused by the sky or clouds being reflected in the water; it can eliminate that "hazy" look you sometimes get.

Have a diffuser handy, too. A diffuser will help to control high-contrast problems you may encounter on sunny days.

Use a tripod. Not only will it steady your camera, allow you to use slower shutter speeds, and improve your composition, it will free up your hands for other important things like catching yourself when you slip.

Cautions: Tide pool areas are notorious for slippery kelp and sharp rocks and barnacles. Wear sturdy and supportive footwear, and be careful of where you step. It's very easy to take a spill on the rocks or land backside first in a tide pool—though this is more injurious to your dignity than anything else. Seriously, be careful with your footing.

You'll also want to keep an eye on incoming waves and know when the tide will be changing.

Oregon State Parks

Oregon has one of the finest state park systems in the country. Over 60 separate sites along the coast offer access to coastline, trails, lighthouses, historical sites, and more. Some sites require day-use fees

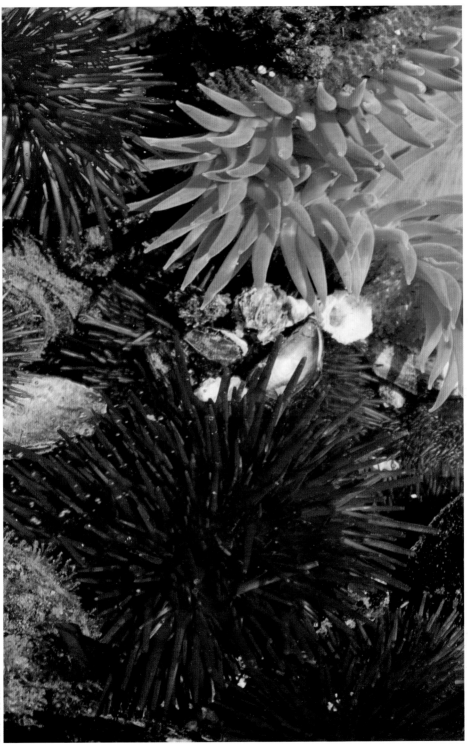

of $3, so if you're planning on spending a significant time photographing the coast, a wise investment would be a $25 annual pass ($20 in April and December).

Annual passes are available by calling 800-551-6949. You can also go on-line at http://www.oregonstateparks.org/dayuse_permit_vendors.php for a list of day-use permit vendors. If you're camping in a state park, your receipt also serves as a day-use permit for that night and the following day in any of the day-use fee areas. So if you plan to camp in the state parks your entire trip, you won't need a day-use pass.

Camping

There are 18 state park campgrounds along or near the coast, most with full hook-ups and hot showers. Sites in some parks even have cable TV hook-ups. Many parks have yurts and cabins in addition to tent and RV sites. The yurts have electricity, a couch, table, bunk beds, and plenty of room. The cabins have electricity, running water, bathrooms, outdoor gas grills, and room to spread out. Some even have televisions with built-in VCRs.

Campsites can fill quickly in summer, so make reservations in those campgrounds that take them. Reservations can be made by phone or on-line. Call Reservations Northwest at 800-452-5687, or go online at www.oregonstateparks.org.

Several places along the coast, most notably Cape Perpetua, also require a Northwest Forest Pass day-use parking permit. If you have a Golden Eagle Passport, this will suffice in most places. Otherwise there are often machines that issue day-parking passes. More information and annual passes are available online at http://www.fs.fed.us/r6/feedemo/.

Some General Cautions

Tides: If you're photographing from the beaches or the rocks along the coast, being aware of tides is not only vital to your safety, it's an important photographic consideration.

Tide pools are best photographed at low tide. Crashing waves are better during incoming high tides. Some places, like Devil's Punchbowl, look better during a high tide.

If you're out exploring a beach and rounding headlands in search of the perfect sunset spot, you don't want to get cut off by high tide. Pick up a tide table, or go online to get tide information for the area you'll be in.

Cliffs: The cliffs along the coast are one of Oregon's major attractions. But cliffs can be dangerous, especially those topped with loose soil and vegetation—they can go at any time. Exercise caution. Often a great temptation is to get as close to the edge as possible to get just the shot you want. Believe me I know the feeling. Just beware of the very real danger.

Wind: Wind along the Oregon coast can get pretty ferocious, especially in winter. Every year it seems a storm will occur someplace with winds near 100mph. Summer winds can get pretty stiff, too. Be careful with wind, especially if you're near the edge of a cliff. Also, wind tends to blow a lot of sand and salt spray about, which your camera will hate.

Sand: Hiking in sand can be very strenuous; a mile on level sand seems more like 3 miles on an uphill trail—at least to me. So when you're contemplating a hike with heavy photo gear, keep this in mind.

Sand can also wreak havoc on lenses,

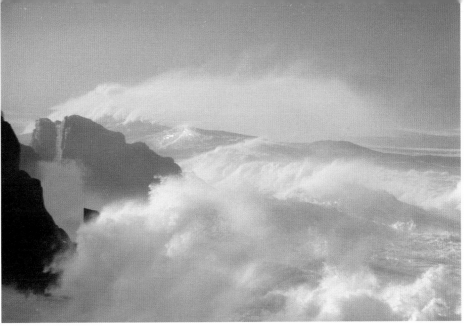

Storm waves

film, and the internal workings of cameras. With the amount of blowing sand you're likely to encounter, it's a good idea to take some precautions:

Protective filters—If you know you're going to be in a sandy area, have a protective filter for your lenses. Then if any sand gets blown into the front of your lens, it will only damage the filter.

Changing lenses and film—Here's when the insidious sand monster commits most of its mischief. So when changing lenses and film, turn your back to the wind. Try doing the changing inside a jacket. In extreme cases have a large plastic bag with you to change film and lenses in—though the wind may just blow the bag away. If possible, return to your car to change film and swap lenses.

Salt Spray

Probably even more dangerous to your camera than sand, salt spray ruins lens coatings as well as camera electronics.

The same sand-related cautions and advice apply.

Marine Mammals

Do not approach marine mammals on the beach. Seal pups that appear to be abandoned really aren't in most cases—Mom's just out getting dinner. If you really want to photograph a seal or sea lion on the beach, use a long telephoto lens like a 500mm or 600mm so you won't have to approach too close.

Storm Photography

Winter can be a fantastic time to visit the Oregon Coast; storm-driven waves crashing over 100 feet in the air can make for some really dramatic images. But stormy weather can also be dangerous—for you and for your camera. Always be aware of the ocean, and don't turn your back on it. Don't get too close to cliff edges either—winter storms are when a lot of cliff erosion occurs.

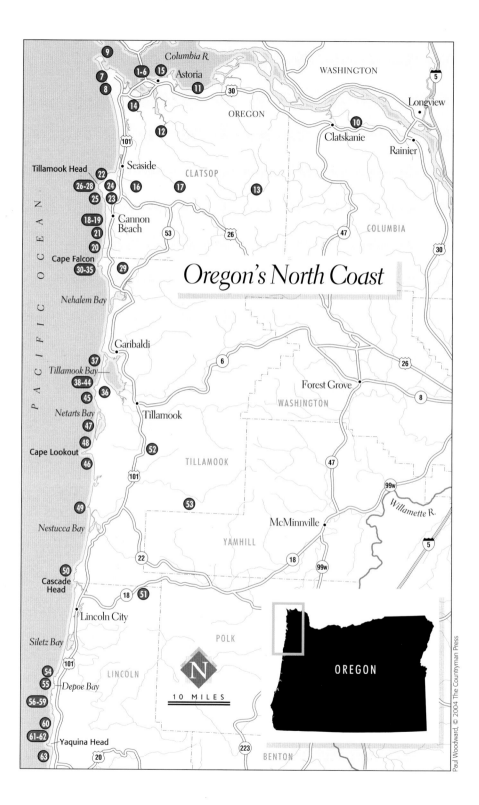

Oregon's North Coast

Columbia R.

WASHINGTON

OREGON

Longview

Astoria

Clatskanie

Rainier

CLATSOP

COLUMBIA

Tillamook Head

Seaside

Cannon Beach

Cape Falcon

Nehalem Bay

PACIFIC OCEAN

Garibaldi

Tillamook Bay

Forest Grove

WASHINGTON

Netarts Bay

Tillamook

Cape Lookout

TILLAMOOK

Willamette R.

Nestucca Bay

McMinnville

YAMHILL

Cascade Head

Lincoln City

Siletz Bay

POLK

N

10 MILES

OREGON

LINCOLN

Depoe Bay

Yaquina Head

BENTON

Paul Woodward, © 2004 The Countryman Press

The North Coast

I. Astoria Area

SPRING ★ ★ ★ SUMMER ★ ★ ★ FALL ★ ★ WINTER ★ ★

General Description: Sitting near the mouth of the mighty Columbia River, Astoria is the oldest city west of the Mississippi, full of interesting historic buildings and sites. Immediately west of Astoria is the Clatsop Spit, a long, sandy point marking the end of the Columbia River and the edge of the Pacific Ocean. There's a lot of history to explore plus good spots for wildlife.

Directions: Astoria sits at the northern end of Route 101 (the Coast Highway) on the southern bank of the Columbia River. Route 30, from Portland, also ends at Astoria. The rest of the coast is south down Route 101.

Specifically: For a wonderful combination of beautiful old buildings and an historic waterfront with lots of nature close by, Astoria is the place. Astoria has more buildings (20 plus) on the National Historic Register than any other town in Oregon. And nearby are places to see bald eagles, elk, and thousands and thousands of migrating birds.

> **Where:** The very north tip of the coast
> **Noted for:** Historic buildings, Columbia River, waterfalls, and wildlife
> **Best Time:** May
> **Exertion:** Minimal
> **Peak Times:** Spring: May; summer: June; fall: late October; winter: January
> **Facilities:** At developed sites
> **Parking:** In lots
> **Sleeps and Eats:** Many in Astoria
> **Sites Included:** River Walk, Astoria Column, Historic Homes, Flavel House, River Viewing Tower, West Mooring Basin, Fort Stevens State Park, The *Peter Iredale,* Clatsop Spit, Lower and Upper Beaver Falls, Twilight Eagle Sanctuary, Youngs River Falls, Jewell Meadows Wildlife Area, Fort Clatsop National Memorial, Columbia River Maritime Museum, Klootchy Creek Spruce, Saddle Mountain

River Walk (1)

The best introduction to Astoria may be strolling the Astoria River Walk. This approximately 4-mile paved path follows the edge of the Columbia River from the East Mooring Basin (on the east side of town) to the West Mooring Basin (on the west side of town). Along the way you'll pass lots of old docks and crumbling buildings but also the Columbia River Maritime Museum, Fort Astoria, the River Viewing Tower, the Doughboy Monument, the Maritime Memorial Park, and pass under the 4-mile-long Astoria Bridge that crosses the Columbia River.

The River Walk may not be picturesque the entire way, but it is always fascinating, and you'll see parts of Astoria that most tourists don't. Prefer to pick up the path midway? Just walk toward the river from anywhere on Route 30 (Marine Drive) in town.

Astoria Column (2)

The Astoria Column is a 125-foot column covered with 14 paintings depicting 22 events in Oregon's history. While interesting in itself, photographers will be most interested in the spectacular panoramic views from its 600-foot perch. It really is worth climbing the 164 steps. But even the view from the parking lot is fantastic; Astoria, the Bridge, and the Columbia River are at your feet. The view is north, so it's good at any time of the day.

If you're staying in or near town, the column makes an excellent location for either sunset or sunrise photos. At sunrise you might even get to photograph the column shrouded in mist. You'll need a wide-angle lens to photograph the entire column.

For photographing the town and bridge from the picnic area or atop the column, try including part of the winding road leading to the column.

Directions: Turn on Fifteenth Street and head up hill, following the signs. Plenty of signs in town guide you to the column atop Coxcomb Hill. To help even further, column symbols are painted on the pavement to keep you going in the right direction.

Historic Homes of Astoria (3)

Astoria is known in the Northwest as Little San Francisco because of its numerous and beautifully restored Victorian buildings. The most thorough way to see them is to pick up a booklet titled *Walking Tour of Astoria* (available at the Astoria Column gift store, at museums, and at many shops in the city). Inside you'll find a map and descriptions of the 70-plus historical homes along a 1.4-mile route.

Alternatively, just head uphill from the waterfront, and wander. There are many beautiful homes along Franklin and Grand Avenues.

Flavel House (4)

This historic Victorian landmark is now the Clatsop County Historical Society Museum. Built in 1885, the Queen Anne house was the home of Captain George Flavel, one of the first licensed Columbia River bar pilots and also Astoria's first millionaire.

To photograph this home, you'll need to get close enough, using a wide-angle lens, to keep the power and telephone lines out. It seems the best place from which to photograph happens to be in the middle of the street. Watch out for cars coming down Eighth Street, as their drivers "don't seem to care about speed limits or pedestrians," as one local related.

Directions: From the bridge and the intersection of Highway 101 and Highway 30, drive east for 1 mile, and turn right (south). Flavel House is one block up.

River Viewing Tower (5)

The Tower has grand views of the waterfront and the river. You may even see some seals or sea lions. The Columbia River shipping channel passes just offshore from the tower, so it's a good place to photograph ship traffic. I think the photography is best in late-afternoon light.

Directions: The tower is 1 mile east of the Astoria Bridge (junction of Highway 101 and US 30). Look for a sign to the viewing tower. Turn on Sixth Street, and drive a short block; you'll see the tower in front of you. There's plenty of street parking.

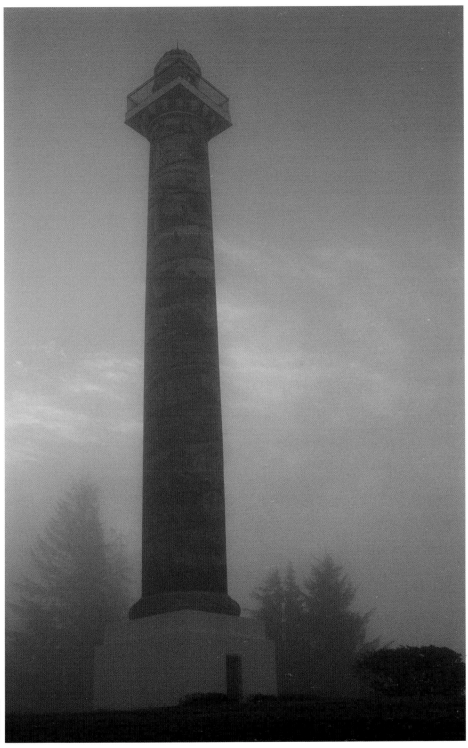

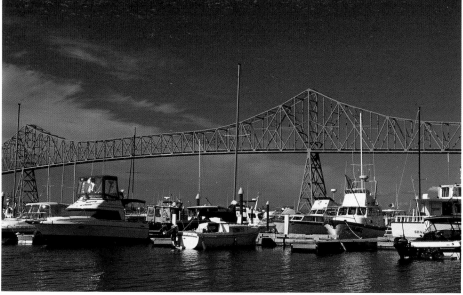

Astoria Bridge from West Mooring Basin

West Mooring Basin (6)

The West Mooring Basin, just west of the Astoria Bridge, is the largest congregation of boats in Astoria. There are lots of harbor shots to take, plus you'll have a great view of the Astoria Bridge. I think the best shots are of the bridge with the boats in the foreground.

This location would be excellent at sunset with the last light of day bathing the bridge in warm colors—even better if a few clouds reflect in the water. It would also make a great sunrise location, with the pinks in the sky reflecting in the water or perhaps some fog and mist shrouding the bridge. There are many possibilities here.

Directions: From Highway 30 in Astoria, drive toward the bridge and the Highway 101 interchange. Look for a Red Lion Inn on your right. Turn at either Basin Street, just east of the junction, or Portway Street, just west of the junction. Park by the Red Lion, and walk down to the Mooring Basin.

Fort Stevens State Park (7), the *Peter Iredale* (8), and Clatsop Spit (9)

Fort Stevens State Park, the largest state park in Oregon and also the largest west of the Mississippi, occupies the northernmost tip of the coast of Oregon. Part wild and part developed, the park has a little bit of everything, including 5 miles of hiking trails and 7 miles of bike trails.

Fort Stevens was originally a Civil War fort built to protect the approach to the Columbia River. It remained an active fort through World War II. In fact, in 1942 a Japanese submarine fired on the fort but missed and caused no damage. The wilder areas of the park are covered with Sitka spruce and wild rhododendrons, dense ferns, and exotic yellow skunk cabbages. And the mighty mouth of the Columbia River—known to mariners as "the Graveyard of the Pacific" because of its treacherous waters—is just offshore.

If history is your thing, this park is a must stop. You can walk inside the old

batteries (you'll need a flash), an old guardhouse, barracks, and Civil War–era earthworks. And Civil War reenactments regularly take place in the summertime.

Photo opportunities also include a shipwreck, the *Peter Iredale,* a British bark that ran aground in 1906. Only the iron skeleton remains, but it makes an interesting silhouette for sunset pictures. To get to the wreck, drive to the campground entrance, and continue straight at the four-way stop. Follow signs for *Peter Iredale.*

From the day-use entrance, follow the park road to the end of **Clatsop Spit.** A viewing platform is on the south jetty side (west side), and the Trestle Bay wildlife viewing bunker is on the Columbia River side. This is also a good place to view and photograph oceangoing ships leaving or entering the Columbia.

From the south jetty viewing platform, you might see harbor seals and gray whales as well as cormorants and other birds. From the Trestle Bay viewing bunker, you might see bald eagles, great blue herons, and others. Fall, winter, and spring are best. You'll definitely need a long lens if you want a chance at good wildlife shots. Otherwise, use a wide angle to a moderate telephoto, and try for environmental portraits of your subjects—which is a fancy way of saying, "Place your subject in the landscape."

Other wildlife opportunities include Coffenbury Lake at the south side of the park near the camping area. A trail loops around the lake, which wood ducks and beavers inhabit. There's parking at the head of the lake as well as farther down the lake, where you can also rent boats. There's also wildlife viewing near Swash Lake. Roosevelt elk, deer, beavers, and wood ducks are all potential subjects here.

Directions: From Astoria, drive Highway 101 south across Youngs Bay, turning right on the Warrenton-Astoria Highway, following the signs to Fort Stevens. The road will take you through the town of Hammond. At the stop sign go straight, again following the signs to Fort Stevens Historical Sites. This is where the main historical sites are located in the park.

Coming from the south, look for signs to Fort Stevens about 6 miles north of Seaside. Be sure to pick up the Fort Stevens brochure, which has maps and other useful information.

Lower and Upper Beaver Falls (10)

Lower and Upper Beaver Falls, on the Beaver River, are nice little falls close to Astoria and well worth a visit. Upper Beaver Falls is the first falls you'll come to, and it's right along the side of the road. From the roadside, you can see the falls drop about 15 feet into a wide pool, but for a better photographic opportunity, you should scramble down a short but very steep path to the edge of the pool. Be on the lookout for tires and other trash in the water.

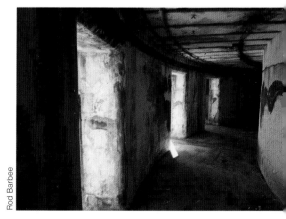

Gun battery interior of
Civil War-era Fort Stevens

Rod Barbee

The falls are good in the spring and early summer, when water levels are up and the falls even more impressive. In autumn you can use colorful leaves as a bit of interest for your foreground. Photo possibilities exist looking upstream, as well.

Farther down the road a short trail leads to the river at the top of the 60-foot lower waterfall. The problem here is that there isn't a real good photographic view of the falls, and what view you can get is very dangerous.

The only good view of the lower falls is where it plunges over the edge of the cliff. Follow the obvious trail, keeping to the right, and it will lead you to a place where you can see the falls going over the cliff. The terrain here is steep and the footing precarious. If you do choose to take a look here, please be VERY careful. One slip and it is all the way to the bottom for you.

Directions: From Astoria drive east on Highway 30. About 6.5 miles from the traffic light in Clatskanie, turn left onto Lost Creek Road. At the stop sign (0.1 mile) turn left, and drive 1.3 miles to the upper falls, which is right next to the road.

Lower Beaver Falls is another 1.6 miles up the road. This turnout isn't as obvious as the one for the upper falls, but there's room for a couple of cars on the left side of the road (if you're coming from the upper falls.)

Twilight Eagle Sanctuary (11)

The Twilight Eagle Sanctuary is a 34-acre marshland preserve that borders the edge of the Columbia River and the channel that separates Svensen Island from the mainland. The best time to visit the preserve to see bald eagles is in winter or when the salmon are running in the fall.

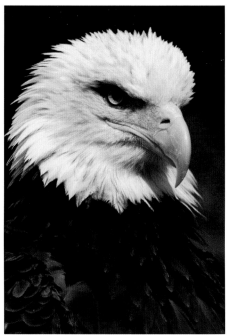

David Middleton

Bald eagle

The rest of the year you are only likely to see an eagle fly by, and the photography will be difficult. An observation platform looks out over the marsh and toward the island, where eagles will most likely be seen.

Directions: Traveling east from Astoria on Highway 30, turn left 0.25 mile past mile marker 88 (about 7 miles from Astoria) onto Burnside Loop. The observation platform is about 0.5 mile down this road.

Youngs River Falls (12)

On March 1, 1806, members of the Lewis and Clark expedition came upon this pretty falls. It is still a forested area, and I imagine as pretty as it was back then.

Photograph from right next to the interpretive sign, or, for better shots, follow

the short trail to the left down to the river and the base of the 50-foot falls. Wide-angle lenses work nicely here. Use the rocks around the pool at the base of the falls for foreground.

Take a look downstream from the falls, as well. The stream here is very pretty, and there are some nice reflections to photograph in the slow water pools. Spring and early summer are great for picture taking because of the new foliage and more water coming over the falls. It will be colorful in autumn, but the water level may be lower.

Directions: Follow Highway 202 south of Astoria approximately 10 miles to the Youngs River Loop Road at Olney. Turn right (south), and drive about 5 miles to a turnoff for the falls. This road ends at a parking area.

Jewell Meadows Wildlife Area (13)

This 1,184-acre refuge is dedicated to the restoration and protection of Roosevelt elk. Once common in the Northwest, these smaller cousins of the Rocky Mountain elk became rare during the logging boom. Jewell Meadows is now the most reliable place to see and photograph Roosevelt elk in the state.

Located around the former mill town of Jewell, the wildlife area is a string of large meadows along the side of Route 202 west of Jewell and along Beneke Creek Road, north of Jewell. This remote area still shows the strong hand of logging, but it's well worth the trip if you're a serious wildlife photographer.

September through March the elk are seen almost daily. If they're not there when you're driving by, go find something else to do for a little bit. Chances are the elk will be there when you get back. Or wait around. Best viewing is in November, when many elk are out most of the day. They aren't present on the refuge in summer, but you have a pretty good chance of seeing black-tailed deer and coyotes at that time of year. Be patient, and you never know what you might see.

Directions: You can get to Jewell from just about any direction—none of them very easy. The best way is from Route 26, which travels between Route 101 on the coast and Portland. Once you're in the middle of nowhere, look for Jewell Junction and Route 103 heading north. Follow this for 9 miles to the little town of Jewell.

Fort Clatsop National Memorial (14)

Lewis and Clark spent the winter at Fort Clatsop after laying eyes on the Pacific Ocean and before their return journey back to the Mississippi. No trace of the original fort remains, but the National Park Service has faithfully reconstructed it, based on the floor plans and dimensions as drawn by Clark.

This is mostly a spot for the serious history buff. It isn't particularly pictur-esque, but it is interesting, and if there are interpreters dressed in period costumes around, it's possible to get some wonderful shots. You'll need a tripod and a wide-angle lens to photograph the interior portions of the fort because the rooms are very small.

For the most authentic pictures, visit on a dreary, rainy winter's day, and photograph the fort in the same conditions that the explorers experienced. You'll be glad you were born a century later.

Directions: From Astoria follow either Highway 101 or BUS 101 south, and

look for the Fort Clatsop National Memorial signs. There's an entrance fee, but your National Park Pass will get you in.

Recommendations: As with anywhere on the coast, if it's sunny, avoid forests and waterfalls because it will be too contrasty to get good pictures. Instead, head for the coast and do crashing waves, or work harbors where reflections can be outstanding on sunny days. If it's cloudy, just the opposite is true: Water will appear leaden, so the ocean and harbors won't photograph well, but waterfalls and forests will be great.

To best photograph beaches, walk as far away from the parking lots as you can. This will both get rid of most footprints and increase your chances of finding something neat to photograph. And don't forget to wander in the dunes if you're allowed. Often wonderful pieces of driftwood and lots of wildflowers are hidden in the dunes, which most people ignore in their rush to get to the ocean.

Pro Tips: A wide-angle zoom lens is all you really need inside museums or the fort. You may want to use flash on occasion, and you'll need high-speed film or a high ISO setting on your digital camera since these places prefer that, for safety, no tripods be used. Also be aware of the lights. Most of the displays are illuminated with tungsten lighting. If you're shooting film, you either need tungsten film or an 80-series filter. If you're shooting digital, set your white balance for tungsten lighting.

But look out. Some of the displays are in areas with lots of outdoor light from windows. Here you'll have more of a bluish light since you're basically in the shade. With film, you can either shoot it straight or add a slightly warm filter like an 81A. With digital, set your white balance to a shady light setting, and check your monitor. You may need to fine-tune the white balance just a bit if your camera has that capability.

If you're photographing moving water on a bright day, and you want to get that soft-water effect, use a shutter speed longer than one second. But on a sunny day, there may be too much light to get the shutter speed you want. To slow your shutter: Use your smallest aperture opening, f/22 or f/32. Use slow (ISO 50) film. Putting a polarizer on your lens will cut 1 to 2 stops of light. Add a neutral density filter (not a graduated ND). The easiest thing to do is wait for a cloud to come by, and shoot when the scene is the darkest. It should go without saying that you'll need a tripod.

Cautions: Rocks at stream edges can be very slippery. This is especially true around waterfalls. No picture is worth a serious fall, and every fall at a waterfall is serious. Be careful.

Plus I know I shouldn't have to state this, but don't rent a boat and go for a joyride on the Columbia River. It's very easy to get pulled into the current and simply disappear. I don't care if you are an experienced skipper. The mouth of the Columbia is well beyond your capabilities. If you decide to ignore this advice, leave this book on the dock so that someone else can use it.

Diversions: If you have any interest at all in the sea, sailing ships, fishing, history, or the human spirit for challenge and adventure, you simply must visit the **Columbia River Maritime Museum (15),** located in the middle of Astoria along the water-

front. And if you're not all that interested in the sea, you will be by the time you leave. Here you'll find beautiful ship models, from old sailing ships to modern tankers. You'll also see displays of coast guard rescue ships, fishing vessels, the bridge of a World War II–era navy destroyer, Native American fishing tools and techniques, and a whole lot more.

Nearby: The **Klootchy Creek Spruce (16),** located in Klootchy Creek State Park—on Route 26, 2 miles west of the Coast Highway—is said to be the largest Sitka spruce in Oregon. It is certainly the largest tourist-attracting tree in the state. Photographically, though, it isn't a particularly pretty scene because the forest around it is small and tattered and always surrounded by throngs of people. Wondrous to see, but leave your camera in your car.

If you're interested in a serious hike to a serious view, climb up **Saddle Mountain (17).** Go in May or June, and you'll find the best wildflower display on the entire coast. The outing will cost you because it's a 1,620-foot elevation gain and 5 miles round-trip, but the rewards are great. Not only will you have bragging rights, you'll get pictures nobody else has. On a clear day you can see the coast, much of the Coast Range, the Columbia River, Mount Rainier, Mount St. Helens, Mount Hood, and everything in between.

Directions: Saddle Mountain is 10 miles east of Seaside on Route 26. Follow the signs to Saddle Mountain State Park and then to the trailhead.

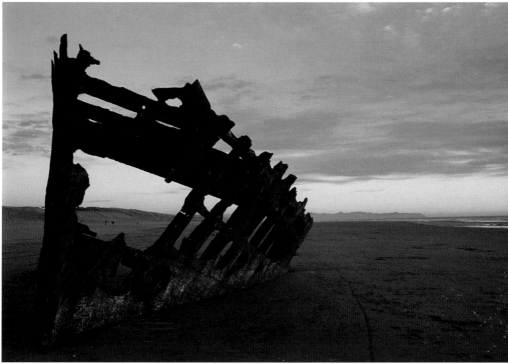

Rod Barbee

Wreck of the Peter Iredale *at sunset*

II. Cannon Beach Area

General Description: The Cannon Beach area is a well-known destination for both tourists and photographers because there's a little bit of everything to keep everyone happy: beautiful beaches with picturesque rocks just offshore, great vantage points for dramatic views of the coast, and plenty of crashing waves and quiet tide pools.

Directions: Cannon Beach is a few miles south of the intersection of Highway 101—the Coast Highway—and Route 26.

Specifically: Cannon Beach is a small, tidy resort town built on a beach with the same name, so you will want to sleep *in* Cannon Beach but walk *on* Cannon Beach. Immediately offshore is Haystack Rock, a huge sea stack that's a very popular photo subject. The area is protected between two prominent capes: Tillamook Head to the north and Cape Falcon to the south. These capes are both undeveloped and worth exploring.

> **Where:** North coast between Astoria and Tillamook
> **Noted for:** Offshore rocks, dramatic coast, beautiful beaches
> **Best Time:** May
> **Exertion:** Minimal
> **Peak Times:** Spring: May; summer: June; fall: late October; winter: January
> **Facilities:** At developed sites
> **Parking:** In lots
> **Sleeps and Eats:** Many in Cannon Beach
> **Sites Included:** Cannon Beach, Haystack Rock, Hug Point, Tolovana Beach State Recreation Site, Ecola State Park, Ecola Point, Old-Growth Spruce Forest, Indian Beach, Tillamook Rock Light, Tillamook Head Trail, Tillamook Head, Oswald West State Park, Cape Falcon View, Short Sand Beach, Sand Creek Old-Growth Forest, Smuggler's Cove, Cape Falcon, Coastal Views

Cannon Beach Area

Cannon Beach (18) is a resort town with lots of shops and restaurants to explore when the light is crummy. You'll find galleries, antiques shops, kite shops, and, of course, espresso stands. It's cute, but it's also crowded—especially in summer. If you're allergic to crowds, you may want to limit your time here. On the other hand, if you like these sorts of things, you'll find plenty of subjects to point your camera at just by walking around town.

Out on the beach are all sorts of opportunities for pictures of **Haystack Rock (19)**, the local icon. The best access is from Haystack Rock Public Parking, on the corner of Hemlock and Gower. Park, cross the street to the Surfsand Resort, and follow signs for beach access.

Good times to photograph are late afternoon to sunset as well as early morning when the sky is pink and blue. Look for reflections of the rock in nearby tidal pools. At low tide you'll be able to find sea stars and other critters, and Haystack Rock itself is home to many birds such as oystercatchers, puffins, cormorants, and murres.

During the day you'll find kite flyers,

Frisbee-playing dogs, and any number of other "people shots." Cannon Beach's popular Sandcastle Day is held every year in mid-June. Master sandcastle artists come from around the world to participate in the contest.

Directions: Cannon Beach is a few miles south of the intersection of Highway 101 and Route 26.

Hug Point (20)

Hug Point is a small, easily overlooked pullout on Highway 101 that got its name because—before there was a coastal highway—one had to use the beaches to get from place to place, and on this part of the coast one had to hug this point to get around it. Even then it was only passable at low tide. Eventually a narrow road was blasted into the rocks to make the passage easier.

While the beach isn't initially impressive, if you walk up it, you'll find a couple of small sea caves, a nicer beach, and Fall Creek Falls cascading onto the beach just before the rugged headland of Hug Point. Beyond the falls is the narrow passage around the point itself. If you like walking, you can continue another 5 miles north along this beach and around Humbug Point all the way to Cannon Beach.

The best views from the parking area are to the north up the beach, using wide-angle to normal lenses. The point itself is best photographed in late afternoon and at sunset. Easy access to the beach makes this location a quick and easy photographic stop. The sea caves and waterfall are north up the beach from the parking lot.

Directions: On Highway 101, 1.2 miles south of Arcadia Beach State Wayside and about 2.2 miles north of Oswald West State Park.

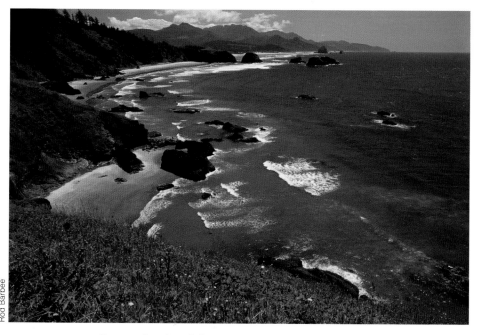

Rod Barbee

Crescent Beach and Cannon Beach from Ecola State Park

Tolovana Beach State Recreation Site (21)

Just south of Cannon Beach, the Tolovana Beach Wayside has good beach access and a great view of Haystack Rock. This is a great place to photograph kite flyers, kids on the beach, couples walking hand in hand, dogs with their humans—with a backdrop of Cannon Beach, Haystack Rock, and Tillamook Rock Light in the far distance.

Directions: Tolovana Beach is just south of Cannon Beach on Beach Loop (or Hemlock) Road. Look for the sign on Highway 101 to Tolavana Beach. The beach is right next to Mo's Chowder Restaurant—a coast must-eat!

Ecola State Park Area

The view of Cannon Beach from **Ecola State Park (22)** is one of the most photographed views on the Oregon Coast—and for good reason. This sweeping view south captures the curving coast, with Cannon Beach tucked into its hills and Haystack Rock just offshore.

The park's entrance road winds through a lush spruce forest on its way to the entrance station. Foggy or rainy days make this forest a magical place to photograph. The road is narrow, and parking is not allowed on the shoulders, so if you see something you want to photograph, you'll have to hike back to it.

At the entrance station you can turn either left or right. Turning left will take you the **Ecola Point (23)** picnic area. At the west end of the parking lot, a trail leads to viewpoints. I suggest walking the entire short route first before deciding from where you'd like to photograph. Most likely you'll find several spots.

The view south toward Crescent Beach and Cannon Beach is spectacular. Late afternoon is a good time to photograph from here since the incoming surf below will be accented by the low side lighting. Compose your image so that the beach curves from lower right to upper right in a long C shape. This is also a perfect place for panoramic images, whether you use a panorama camera or you stitch your pictures together digitally.

From the parking area, a paved trail leads at first downhill to the left, skirting a picnic area on the right. It then climbs up and curves around to viewpoints. At the point where this trail bottoms out before it starts climbing again, a grassy area is on the left. Keep your eyes open for a faint trail that leads maybe 50–60 feet to a good vantage point. Continuing on the main paved trail will bring you different views from more vantage points. At the top a wooden safety rail keeps you from plunging to your death.

From the park's entrance station, if you turn right, you'll head toward Indian Beach. Like the main road leading into the park, this road also winds through the **old-growth spruce forest (24),** but here you have more parking opportunities. If you come on a foggy or drizzly morning, linger and take advantage of these conditions in this beautiful forest.

At the end of the road is **Indian Beach (25),** a very popular surfing beach. The trail to the beach is located on the south side of the Indian Beach parking area. Walk south for about 100 yards or so, and you'll be able to see the **Tillamook Rock Light (26)** far out to sea. Indian Point is to your right, and if you put yourself in the right place, you'll be able to line up the bird-filled rocks at the end of the

point with the lighthouse in the background. You'll need a long lens: at least 300mm and preferably a 500mm or 600mm. By the way, the view north from the parking lot to Ecola Point is well worth photographing.

Keep walking south down the beach for shots of waves crashing against the large rocks in the surf. Try shooting the waves from the side, or position yourself behind one of the rocks, and time your shot to capture the water crashing over the top of the rocks. Don't get too close, or *you'll* be crashing against the rocks, as well.

An even better view is from the nearby **Tillamook Head Trail (27).** This 1.8-mile trail, which starts from behind the rest rooms, first follows an old road, then—in about 100 yards—turns left onto the Tillamook Head Trail and climbs a short distance to a wind-blown, bonsai-like spruce tree. Photograph from under the spruce, or stand back a bit and use it to frame your composition. Wide to normal lenses and short telephotos work well here, depending on your photographic goal: the sweeping landscape of the beach and the rocky point, isolating the rocks at the point, or even some of the surfers below.

The trail continues to the tip of **Tillamook Head (28),** where there are more impressive views and an old World War II radar bunker to explore. This is as close as you are going to get to Tillamook Rock Light, but it's still 1 mile away. If you want a picture of isolation and loneliness, photograph Tillamook Rock with its crowning lighthouse with nothing but sea around it. Incidentally, the light stopped operating in 1957, and it's now used to store funeral urns. (I can't make this stuff up!)

David Middleton

Old-growth spruce forest

For the truly intrepid, the trail continues to the north all the way to the town of Seaside on Highway 101, following the coastal cliffs high (very high) above the crashing waves. This is not an easy walk, and at more than 6 miles one way from the Indian Beach parking area it requires considerable effort, but the rewards are great, and you'll have pictures none of your lazy friends will have.

Directions: From the north side of Cannon Beach, follow the signs to Ecola State Park. If you're coming in from Highway 101, take the northernmost of the three Cannon Beach exits, and follow the signs to Ecola.

Oswald West State Park Area

Oswald West State Park (29) occupies the entirety of Cape Falcon, a region so rugged that the highway skirts inland to get around it. Because it is so rugged and intimidating, most people don't bother to explore it. You, though, know rugged and remote usually means exceedingly beautiful.

A great **view of Cape Falcon (30)** can be found from an unmarked pullout on Highway 101. A short, easy trail leads to a point overlooking a small cove, a sea stack, and Cape Falcon to the north. You can easily get around the fence for better views, but please be very careful. It's a long drop. Even though the view from this point is good, continue on the trail just above a bench for even better possibilities

Use the sea stack below as an anchoring foreground element, or use the sculpted trees as a frame. This would make an excellent place to photograph in late afternoon and at sunset. It's another one of those places to use when there's not much going on in the sky, and all the action is where the light is falling. It would also work well midmorning with a blue sky for more of a "postcard" image.

Directions: Coming from the south, after you see the signs telling you you're in the state park, look for a large, paved pullout with interpretive signage. Get out and take a look around. But the spot you'll really want to be is 0.3 mile north, a large gravel pullout on your left with room for several cars. Follow the trail leading from this pullout toward the tree-covered cliffs. At a fork in the trail, stay left, heading into the trees.

From the north: Pass the parking areas for Oswald West State Park, and cross the Necarney Creek Bridge. From the southern end of the bridge, drive 0.7 mile to the large gravel pullout.

At the Highway 101 bridge spanning Sand Creek, park at the large Oswald West State Park day-use parking area. A 0.5-mile-long trail leads to **Short Sand Beach (31),** a pretty little beach that's popular for surfing. The trail follows Sand Creek

and winds through a lush **old-growth forest (32).** The forest here is particularly beautiful, especially on an overcast or drizzly day. You may find yourself unable to get any farther because so many images can be found here.

Tear yourself away, and you'll shortly come to a junction with the Oregon Coast Trail. Turn left, cross a high suspension bridge over Necarney Creek, and the beach and **Smuggler's Cove (33)** is quickly upon you. From the beach you'll have a good view of Cape Falcon and probably lots of surfers playing in the waves. Don't want people in your pictures? Just walk a little ways up the beach. Sand Creek empties onto Smuggler's Cove and makes as an interesting foreground for wide-angle landscapes.

If you want to hike out to the tip of **Cape Falcon (34),** turn right on the Oregon Coast Trail instead of left to the beach. It's about a 2-mile hike to the tip of Cape Falcon and well worth it. The point itself is mostly open and very windswept, so the trees and bushes are sculpted into wonderful shapes. This is a magical place in the fog but a dangerous place in a storm because there are no railings marking the cliffs. If you fall here, no one will ever find you.

For **coastal views (35)** of the tip of the cape, continue another mile or so along the trail through the dense coastal spruce forest. Occasional views here look north and back south toward the point of Cape Falcon. If you happen to be here on a pretty calm day (lucky you!), look for whales offshore. They are often very close to the point and wonderful to watch.

Recommendations: The Cannon Beach area has so much to offer, you could

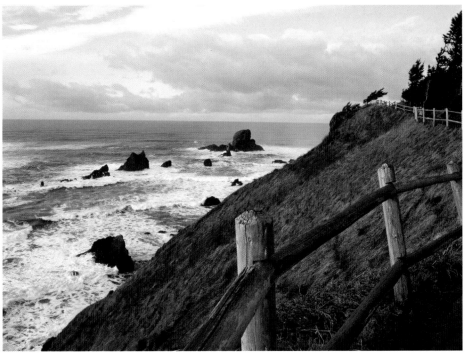

Scott Bourne

Coastal view

spend a week or two here and still have things to photograph. On a beautiful sunny day, take a hike along the beach, or walk out to the tip of Cape Falcon or Tillamook Head. If it's foggy, take the same walk, but don't expect to get very far because there'll be so much to shoot.

If it's a rainy day, head back into the forest, and photograph alder-lined streams or fern-covered hillsides. There is no better time to photograph the forest than in the rain. When the storm ends, head for the rocky coast, and play with the huge breakers crashing against the shoreline.

Pro tip: When photographing people, use a telephoto lens to isolate them and bring the background closer. You'll get pictures that make it look like Haystack Rock or a breaking wave is right behind them.

If you are doing wildlife, be careful of your backgrounds. Pick an angle that places your subject against a complimentary background, not a distracting one. For instance, don't photograph a light-gray gull against light-gray water. Instead, photograph it against a bit of dark vegetation or a distant headland.

Cautions: The trails on Cape Falcon and Tillamook Head are not well used, especially the longer ones. Though appealing to the inveterate hiker, it also means that you'll be in remote country without much chance of help should something go wrong. Tell someone where you're going, even if it's the desk clerk at your hotel, or at least put a note on your car stating when you expect to return. Pride goeth before the tumble down the cliff.

III. Tillamook to Lincoln City

SPRING ★ ★ ★ SUMMER ★ ★ ★ FALL ★ ★ WINTER ★ ★

General Description: The central coast of Oregon is a nice mix of big empty beaches, jutting capes, and woodland waterfalls. Plus the land around the town of Tillamook is dairy farm country, with deep green pastures and old, mossy barns. Add to this the largest wooden building in the world *and* great cheese, and any photographer should be happy.

Directions: Highway 101 links the harbor towns of Tillamook and Depoe Bay, but much of the route is inland, away from the areas of prime interest to photographers. To see the coast, take the Three Capes Scenic Highway instead.

Specifically: Three capes define this part of the coast. From north to south: Cape Meares, with a very photogenic lighthouse; Cape Lookout, a long finger of rock sticking way out into the ocean; and Cape Kiwanda, perhaps the most photogenic of them all. Still farther south is Cascade Head, what I think is the wildest remaining part of the Oregon Coast.

Inland are three nice waterfalls and a very rich and very green farming area surrounding the little town of Tillamook. If that name sounds familiar, it's the home of Tillamook cheese, sold in your grocery store.

Three Capes Scenic Drive Area

The **Three Capes Scenic Drive (36)** begins in Tillamook and runs along the coast for about 32 miles, to the tiny town of Pacific City. All photographers should

> **Where:** Central coast between Cannon Beach and Newport
> **Noted For:** Offshore rocks, dramatic capes, long beautiful beaches, and farm country
> **Best Time:** Late May
> **Exertion:** Minimal to moderate hiking
> **Peak Times:** Spring: May; summer: June; fall: late October; winter: January
> **Facilities:** At developed sites
> **Parking:** In lots
> **Sleeps and Eats:** Scattered along Highway 101
> **Sites Included:** Three Capes Scenic Drive, Bayocean Spit, Cape Meares Lighthouse and National Wildlife Refuge, Lighthouse Loop Trail, Octopus Tree, Lighthouse Views, Three Arch Rocks, Headland Tunnel, Oceanside, Cape Lookout State Park, Netart's Spit, Anderson's Viewpoint, Cape Kiwanda State Natural Area, Cascade Head Preserve, Drift Creek Covered Bridge, Munson Creek Falls, Niagara Falls

take this route. It is longer and slower than Route 101, but the rewards are far greater, and, besides, you're on vacation.

To get to the start of the scenic drive, turn west on Third Street in downtown Tillamook, following the SCENIC DRIVE signs, and then turn right at Bayocean Road, again following the signs. The road takes you along the southern shore of Tillamook Bay, where in summer you're likely to see great blue herons, bald eagles, and pelicans, plus lots of old logging piers and paraphernalia.

As the scenic drive begins to leave Tillamook Bay and round the coast, a long and protected sand spit appears to the north. This is the 4-mile-long **Bayocean Spit (37),** the western edge of Tillamook Bay and one of my favorite places on the coast to explore.

There are two routes to this exploration: Head directly to the beach and walk north for as long as you wish, or walk the old road on the bay side of the spit through thickets of salal and shore pine. Both routes eventually lead to a jetty, known as South Jetty, that marks the end of the spit and the southern edge of the channel leading into Tillamook Bay.

You're more likely to see weird and wild things if you walk the beach, but you'll reach the most remote parts of the spit more quickly if you initially walk part of the road. I actually prefer to walk the road until my eye catches something and then wander around following my whims. I often end up in the dunes, where wonderful landscapes and details occupy me for hours.

Directions: The spit is 6.6 miles from downtown Tillamook on the Three Capes Scenic Drive. Turn right (north) onto a gravel road at the signs. This road ends at a graveled parking area in about 1 mile.

Cape Meares Light and National Wildlife Refuge

Cape Meares juts into the Pacific Ocean west of the scenic drive. About half the cape is Cape Meares State Park, and the other half is part of Cape Meares National Wildlife Refuge. The lighthouse is the big draw, but I always get sidetracked by the old-growth spruce that covers most of the area.

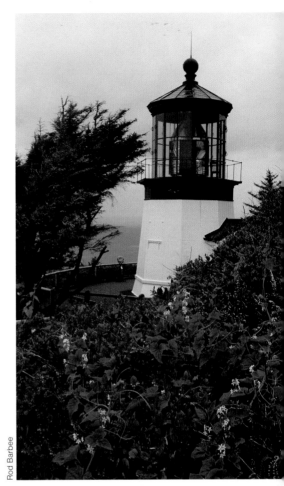

Rod Barbee

Cape Meares Light

Most photographers go to Cape Meares to photograph the **Cape Meares Light (38).** Locals know the lighthouse as one that's great but a bit tricky to photograph. There aren't any obvious compositions of the entire lighthouse, so you'll have to get creative with foreground usage, or try photographing just portions of the structure.

From the parking lot, walk the short, paved loop path to the 40-foot-tall lighthouse—Oregon's shortest—which sits 217 feet above the ocean. As you ap-

proach the lighthouse, you'll be nearly at the same level as the light. Here you can photograph with the top of the lighthouse making up most of your frame. Or try zooming in on the lens itself for more abstract compositions.

Continue down the trail to a junction (which goes right to the lighthouse or left to complete the loop trail back to the parking lot) for what is probably the best view of the entire lighthouse. You'll notice at this trail junction a scant "path" that penetrates the bushes 2 or 3 feet. This is a good spot to put your tripod. Use a wide-angle lens like a 24mm, and get close and slightly above the bushes.

When you're done with the lighthouse, check out **Cape Meares National Wildlife Refuge (39).** At the north end of the parking lot is a wildlife observation platform that looks across a small cove to some cliffs and off-shore sea stacks, where pigeon guillemots, tufted puffins, common murres, pelagic cormorants, and more shorebirds may be seen. The cliffs straight across from the platform are nesting sites for peregrine falcons. The cliffs and islands are too far away for full-frame bird photography, but they make good subjects for seascapes.

Viewpoints along the paved trail to the lighthouse give different perspectives to these cliffs. These viewpoints make excellent sunset locations, especially in summer when the sun sets farther north on the horizon. The cliffs will be bathed in the last light of the day. The second viewpoint, the one closest to the lighthouse, is the best spot for this as you'll have a clearer view. Of course, with a lighthouse just down the path from you, it's going to be hard to pass that shot by.

The trail to the **lighthouse loop trail** (40) and the return side of the loop has excellent views south of the sea stacks and Three Arch Rocks. On this part of the trail, the closer to the lighthouse you are, the more of the arches you'll see. The best spot is just up from where the loop trail meets the short trail to the lighthouse.

When you're in this area be sure to visit the unique, candelabralike Sitka spruce tree known as the **Octopus Tree (41).** This bizarre tree—which some believe is nearly 2,000 years old—is more than 12 feet in diameter at its base. Just 0.1 mile from the parking lot on an easy trail, this tree is worth a visit even if you don't want to photograph it. And some nice ocean views to the south are just beyond the tree.

Try visiting this tree early on a foggy morning. As the sun comes up, you'll be able to photograph the tree backlit, making for very pleasing, very ethereal images. If you're lucky, you'll also get rays of light through the branches.

Directions: The Cape Meares Light and National Wildlife Refuge is 2.2 miles beyond Bayocean Spit on the northern end of the Three Capes Scenic Drive. There are rest rooms, an interpretive display, and viewing platforms.

From the Cape Meares turnoff, drive about 1.4 miles to a spot in the road with parking areas on both sides. A stairway leads to a beach. Park here, and walk up the road about 100 yards or so for good **lighthouse views (42).** When you've found just the right place to photograph from, you'll probably want a moderate telephoto for shots to include the surf, the sea stacks, the lighthouse, and the sunset.

Descend the stairway to the cobblestone beach for shots with a different per-

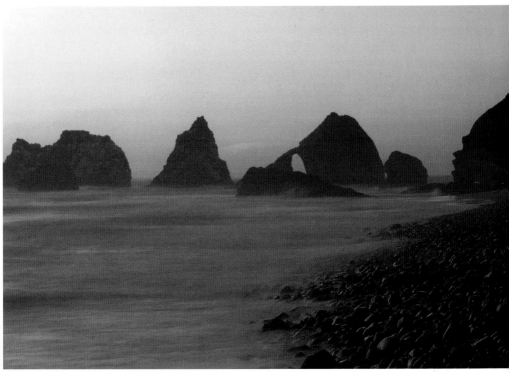

Rod Barbee

Three Arch Rocks at sunset

spective. Use the rocks as foreground subjects, or photograph sunset with the sun going down behind the sea stacks. In winter try photographing some big waves or oystercatcher during the day.

If you continue about 2.5 miles past the Cape Meares lighthouse turnoff on the Three Capes Scenic Drive, you'll come to Oceanside. Turn right, go one block through town, and turn left into the Oceanside Beach Wayside. From the beach you can photograph **Three Arch Rocks (43),** a collection of sea stacks designated as a National Wildlife Refuge in 1907 by President Theodore Roosevelt, the first refuge west of the Mississippi.

For even more dramatic sea stacks, walk north on the beach about 300 yards, where you'll see a **headland tunnel (44).**

A sign cautions you not to enter due to hazards (though the tunnel isn't blocked). Everybody ignores it. The tunnel is about 200 feet long and dark inside. Be careful of points where the ceiling juts out; you could bang your head. A flashlight helps, especially if you're here to photograph sunset.

On the far side of the tunnel, you'll be treated to a collection of sea stacks and arched rocks. Unless it's high tide, you'll be able to walk down the beach toward the sea stacks. Use wide-angle to telephoto lenses here. Photograph the entire group of sea stacks against the sunset sky, or zoom in to feature only an arch or individual sea stack.

If sunset and high tide happen to coincide, you can still photograph from near

the mouth of the tunnel. In late summer the sun will be setting directly behind Three Arch Rocks, making a nice silhouette.

One big caution: Be very aware of the tides. You do *not* want to be caught on the far side of the tunnel—especially during high tides or storms. Though the tunnel is above most high tides, don't take the chance.

The town of **Oceanside (45),** perched on the headland overlooking Three Arch Rocks, also deserves some exploring. Instead of turning left into the wayside parking lot, turn right, and follow Maxwell Mountain Road to its end. You'll

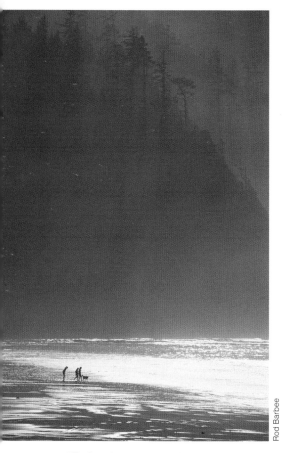

The beach at Cape Lookout State Park

Rod Barbee

have a remarkable aerial view of Three Arch Rocks and the surrounding area.

Back on the Three Capes Scenic Drive, go south toward Netarts about 0.25 mile to another turnout. This point has a good view to the north of Oceanside and Three Arch Rocks. To the south is Cape Lookout.

Cape Lookout State Park (46)

Cape Lookout is a large park with beach access, miles of hiking trails, a nature trail, whale-watching opportunities, and great camping. The cape itself sticks 2 miles out into the ocean like a big finger and is only accessible on foot, so there are lots of wild places to explore. One of the highlights of Cape Lookout is the 5-mile-round-trip **cape trail** that goes to the end of the cape. On a clear day, some of the landmarks that can be seen from the viewpoint at the end of the trail are Tillamook Head 42 miles to the north, Cape Falcon, Cape Meares, and Three Arch Rocks. To the south one can see Cape Kiwanda, 8 miles away, all the way to Cape Foulweather, 39 miles distant.

The tip is a prime whale-watching site. Whales may be off the tip year-round, but peak gray whale migration is November to June. Twenty thousand gray whales pass by this point on their way north to Alaska and then south to Baja. They may not be close (though they could be), but you should be able to see lots of them. Humpback whales summer off this part of the coast, as well.

The relatively easy cape trail leads through old-growth spruce and hemlock. This hike can be magical on a foggy morning: gnarled spruce trees and the sound of the pounding surf, its invisible source somewhere below. When the sun

begins to break through the mist, God beams radiate from behind the tall trees.

A couple of options get you to the Cape Trail. One is to start near the campground on the spit, and hike 2.3 miles to the junction with the cape trail to the end of the cape. The other, easier option is to drive to that trailhead. From the Cape Lookout entrance drive south on the Three Capes Loop Drive about 2 miles to a large parking lot at the trailhead. If you plan on hiking to the end of the cape, it is downhill going and uphill coming back, so only bring necessary photo gear. The trail can be muddy and slippery in places, so sturdy hiking boots are recommended.

The other part of the state park is the 5-mile-long **Netarts Spit (47),** which forms the outer edge of Netarts Bay. A campground and a couple of nature trails are at the base of the spit, but the rest is wild and undeveloped. The farther you go out on the spit, the fewer people you'll see and the more interesting things you're likely to discover. Seals use the tip of the spit as a haul out, as do large flocks of gulls and sandpipers.

The oceanside part of the spit by the campground is a good place to photograph sunsets. In winter the sun sets near the tip of Cape Lookout, allowing both to be in your composition. Find some interesting foreground—like rippled sand or breaking surf—to complete your image.

Directions: Cape Lookout State Park is about halfway along the Three Capes Scenic Drive. You can cut off the Cape Meares part by driving south from Tillamook on Route 101 and turning west on Sand Lake Road. Turn right (north) when you come to the scenic drive to get to Cape Lookout.

Between Cape Lookout and Cape Kiwanda, the Three Capes Scenic Drive follows Sand Lake Road inland around Sand Lake (actually a shallow estuary) and then back to the coast at Cape Kiwanda. About 0.5 mile beyond the Cape Lookout State Park entrance is a wide pulloff called **Anderson's Viewpoint (48).** This is one of the most expansive and impressive views along the Oregon coast. On a clear day you can see all the way north to Cape Meares, with Netarts Spit in the foreground and Three Arch Rocks out to sea.

Cape Kiwanda (49)

Cape Kiwanda packs a lot of photo opportunities into a small area. Unlike most of the other capes on the coast, which have an igneous history (big chunky black rocks), Cape Kiwanda is sedimentary in origin. The rocks look like they don't belong on the coast. In fact, they remind me of the colors and shapes in the sandstone cliffs of the Colorado Plateau—minus, of course, pounding waves and soaring gulls. This means great photo opportunities unlike anywhere else on the coast.

You can photograph the cape and Haystack Rock (the second Haystack Rock on the coast) right from the beach area next to the parking lot, but for the best scenery, hike the beach north a short ways to the cape itself. At low tide there are nice tide pools at the base of the cliffs. Hiking up the beach gives you better views of the colorful water-sculpted sandstone cliffs, and at the end of the beach a trail leads up a sand slope to the top of the cape. From here wander out the cape on the trails to viewpoints showing more shear cliffs and pounding surf.

On top of the bluff where the trail be-

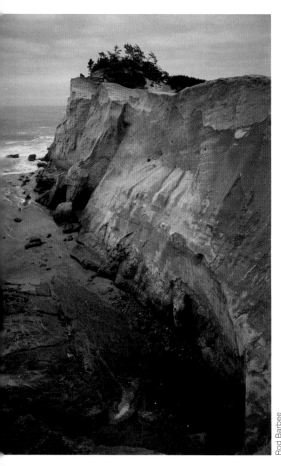

Cape Kiwanda headland

subjects for photographs. And lastly, the beach at Cape Kiwanda is very popular with surfers year-round.

Directions: Fourteen miles beyond Cape Lookout on the Three Capes Loop. Or take Highway 101 south from Tillamook for about 23 miles, and turn right (west) on Brooten Road, following signs to Pacific City and the Three Capes Loop. Cape Kiwanda is just north of Pacific City on the west side of the road, across from The Inn at Cape Kiwanda.

Cascade Head Preserve (50)

This 280-acre Nature Conservancy preserve features native coastal prairie meadows, rare plants and animals, and outstanding views. The meadows are good places to photograph rare and endangered plant and insects, while the forest below offers woodland wildflowers in April and May. If you're trying to get away from crowds, you may not succeed here because the preserve is very popular on nice weekends.

Two main trails lead in to the preserve. The lower trailhead (open year-round) is located at Knight Park at the end of Three Rocks Road. This road is 1 mile north of the Highway 101 and Highway 18 interchange (north of Lincoln City). Turn west onto Three Rocks Road, and follow it to Knights Park. The pretty meadows and views are about 1 mile up this trail.

The upper trailhead, open July 16 to December 31, allows an easier 1-mile hike through the forest and leads to the open meadows. You're in a fragile butterfly habitat here, so stay on the paths. Follow the trail through the meadow as it descends to some fantastic southern views. Continue if you want, but the views don't

gins, you'll see a fence. At the close point of this fence is an opening with a trail that leads down to a small cove. Here incoming surf crashes into sea caves and shoots high into the air. Another viewpoint on the upper trail brings you to a surf-formed arch in the sandstone cliffs. For such a relatively small area, there is a lot to photograph.

In addition to nature photography, there are other things to photograph here. Hang gliders use the north side of the cape to ride updrafts and soar. At the south side of the cape fishermen launch dories during fishing season that are great

get any better. The trail descends quickly, and you'll have a strenuous hike back up the hill—especially carrying a lot of photo gear. The upper trail continues down and eventually joins the lower trailhead.

If you want to avoid most of the crowds and don't care about the high meadows, another trail cuts around the inland side of Cascade Head. This inland trail starts at the junction of Three Rocks Road and Highway 101 and heads north over the back side of the preserve. No views here but lots of forest, mostly second growth, and lots of flowers to photograph in-season.

If you're here in spring and summer, you'll have lots of opportunities to photograph wildflowers and, in the high meadows, some rare flowers such as the pink-colored hairy checkermallow. Be sure to have plant ID books with you. You may also get lucky and see some silverspot butterflies—Cascade Head has one of only six remaining populations of this threatened species. Please remember to stay on the trails to preserve their habitat.

Directions: An easier way to get to the meadows is from the upper trailhead. From Highway 101, drive 4 miles north of the Highway 101 and Highway 18 interchange. Near the top of the hill, turn west on Road 1861. After 3.3 miles you'll see the trailhead parking. Coming from the north, Road 1861 is 0.3 mile south of mile marker 101.

Drift Creek Covered Bridge (51)

Originally located on Drift Creek, this bridge was slated for demolition in 1997. But a local family, the Sweitzes, convinced Lincoln County officials to let them have the bridge, which they hauled in pieces to their property. There they restored the bridge, and it's now open to the public—as part of the agreement with the county, the Sweitz family signed a document

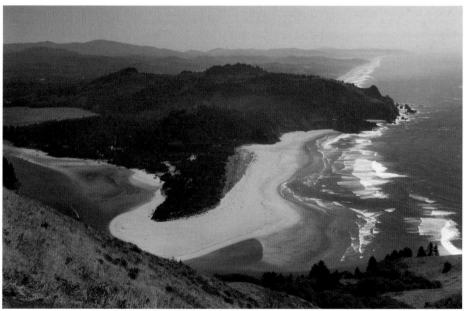

View from Cascade Head

granting public access to the bridge for all time. (Please be aware that this bridge also serves as the driveway to the Sweitz's home, so respect their property.)

You definitely want an overcast day to photograph this bridge; sunny days just cause too much contrast, and you'll be disappointed with the results. The leaves on the surrounding alder trees turn yellowish in fall.

Directions: Just north of Lincoln City; drive east on Highway 18 from Highway 101. About 3.5 miles east of Otis Café, turn south on North Bear Creek Road at a sign for the Drift Creek Covered Bridge. Drive about 1 mile. The bridge is on the left side of the road next to a small parking and picnic area.

Munson Creek Falls (52)

The tallest waterfall in the Coast Range, Munson Creek Falls makes a nice—and quick—side trip. From the end of the trail the only real photographic options are to frame the falls with the surrounding tree branches. For a better view continue on the upper trail, located near the end of the main trail. This steep, rocky 0.5-mile trail leads to a full view of the falls.

Directions: Drive south from Tillamook about 8 miles to a sign for Munson Creek Falls. Turn left (east), and follow the signs for about 1.5 miles to a parking area. The trail to the base of the falls is an easy 0.3 mile walk.

Niagara Falls (53)

Niagara Falls is reached by an easy 1-mile trail that drops gently into a canyon through a nice forest. There are actually two falls here, Pheasant and Niagara. By late summer these falls are reduced to trickles; visit in the spring and early summer when water levels are higher. Niagara Falls faces north, so the sun will be facing you as you're trying to photograph it. Visit on an overcast day when the sun is hidden and the contrast is low.

Directions: About 15 miles south of Tillamook (28 miles north of Lincoln City) turn east at the Beaver onto Road 85, the Blaine–Little Nestucca Road. At about 11.5 miles turn right onto Road 8533. The road sign indicating the way to Niagara Falls is small, so keep a sharp eye out. Keep on this road for 4.3 miles to another road (#8533–121), and turn right. Drive 0.7 mile to a parking area.

Recommendations: If you like solitude, you'll have lots of opportunities to find it here. My favorite lonely places are Bayocean and Netarts Spits, the tip of Cape Lookout, and the inland trail at Cascade Head. On the other hand, avoid Cape Kiwanda and Cascade head on pretty days because they will be crawling with people.

On bright, sunny days photograph the rocks and waves at Cape Kiwanda and Cape Lookout. The shots are best if a storm is coming or there's a strong wind. Remember to photograph water on blue-sky days or the water will be dull gray, not the lovely blue you would like. If it's foggy, run around in a circle shouting joyously, and then dash anywhere you like, and shoot every roll or flash card you have.

Pro Tips: If you're at Cape Meares lighthouse at sunset, try lining up your shot so the setting sun is showing through the glass. You can also try putting the sunset to either side of the light. This will depend greatly on the time of year and the position of the sun.

Something I always try to do when photographing into the sun is to make the sun appear to be a starburst. You do this by using small aperture openings like f/22 or f/32. The more you open up the aperture, the less of a starburst effect you'll get. To minimize lens flare, place the sun so that most of it is behind something—in this case part of the lighthouse. This is a very effective and drama-adding technique that will make your viewers ooh and ah.

To capture the etherealness of foggy landscapes, be sure to get the exposure right. Fog, when exposed as the camera "thinks" is should be, will result in an image that appears heavy and dull. If that's what you're after, then meter the fog, and go with what the camera suggests. But if you want to capture the bright, magical feel of a foggy morning, meter a section of blank fog and open up at least one stop. Trees and other dark objects will likely become silhouettes, but that's OK because the image will look otherworldly and very pretty.

Cautions: There are very real dangers on the coast. The first involves treacherous footing around steep cliffs. I know your photograph is important, but it's better to live to take another one than to go to the big camera store in the sky. The other danger is sneaker waves that surprise unsuspecting photographers and either soak them and all their gear or haul all of it—including the photographer—out to sea. I have seen totally absorbed photographers at tide pools get very unwelcome salt showers. Beware.

Distractions: The **Tillamook Cheese Factory** is the big building at the north end of town; you simply can't miss it. At this popular tourist stop you can see cheese being made, take the self-guided tour, and sample cheese and ice cream. It's pretty good cheese, but watching curds curdle is not the stuff of fascination.

The **Tillamook Air Museum** is housed in a giant blimp hangar, the world's largest wooden structure. Over 30 vintage aircraft, from biplanes to jet fighters, are on display. Just wandering inside this building is impressive. The hangar—visible from anywhere in the Tillamook area—is 2 miles south of Tillamook on Highway 101. Follow the signs, and turn where the A-4 jetfighter is on display.

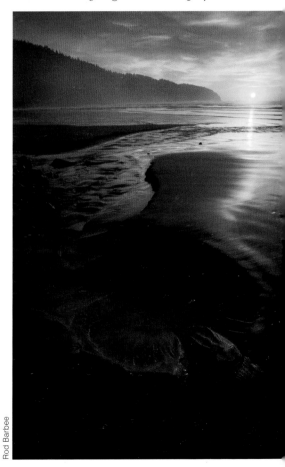

Rod Barbee

View of Cape Lookout at sunset

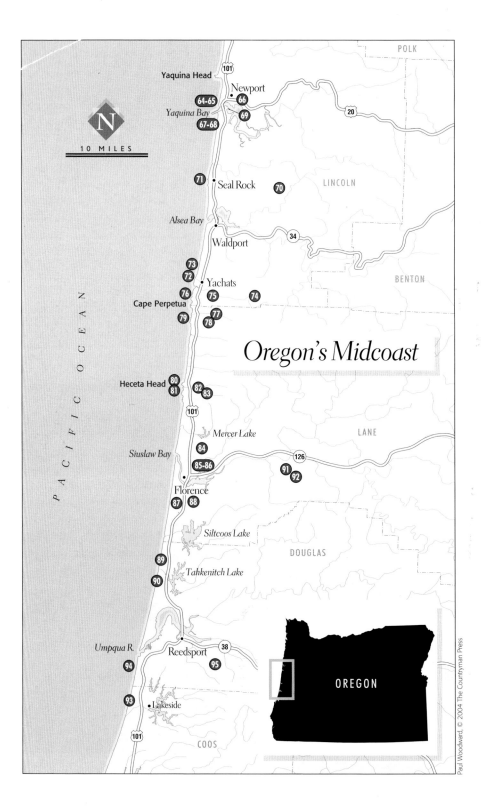

IV. Newport Area

SPRING ★★★ SUMMER ★★★ FALL ★★★ WINTER ★★

General Description: The Newport area is one of my favorite places on the Oregon coast. Everything is easily accessible, and the diversity of sites is outstanding. In one day you can photograph a lighthouse, an old-growth forest, a busy working harbor, and puffins, take a walk on a pretty beach, and then capture sunset through the struts of a tall bridge or reflected in a tide pool.

Directions: The Coast Highway links all the sites included in this chapter. Yaquina Head is a narrow spit just north of Newport; the turn is very well signed. Route 20 cuts through the Coast Range from Newport to Corvallis in the Willamette Valley. Depending on traffic, it takes little more than an hour to get to Interstate 5 from Newport.

Specifically: I have spent more time along this part of the coast than any other. Depending on my mood, I can go out to Yaquina Head and play with the magnificent lighthouse, explore tide pools, photograph seabirds while keeping an eye out for whales, or head to Newport's harbor and get lost in the piles of gear and lines of fishing boats. If it's stormy, I'll go to the wonderful Oregon Coast Aquarium, where there are more things to photograph than is possible in a day.

Where: Midcoast at the junction of Route 20 and the Coast Highway

Noted for: Aquarium, harbors, lighthouse, tide pools, beaches, forest hikes

Best Time: Late May

Exertion: Minimal to moderate hiking

Peak Times: Spring: late May; summer: late June; fall: mid-October; winter: December

Facilities: At developed sites

Parking: In lots

Sleeps and Eats: Many in Newport, some in Depoe Bay and Waldport

Sites Included: Boiler Bay State Wayside, Depoe Bay, Cape Foulweather, Otter Crest Loop Road, Rocky Creek Bridge, Devil's Punchbowl, Moolack Beach, Yaquina Head Natural Area, Yaquina Head Light, Agate Beach, Yaquina Bay Light, Newport Harbor, South Jetty, South Beach, Oregon Coast Aquarium, Drift Creek Wilderness, Seal Rock State Park

North of Newport

Boiler Bay State Wayside (54)

Boiler Bay State Park—about 1 mile north of Depoe Bay—is a tiny, grassy seaside park on a flat, rocky plateau that juts out into the ocean. Boiler Bay is on the north side of the wayside, and at low tide it is still possible to see the top of the namesake boiler above the waves.

This wayside is my favorite place on the coast to photograph crashing waves.

Wait for the day after a storm to get the biggest waves and the chance for pretty light, or go at any high tide and the waves will still be impressive. I like morning for this, but late afternoon when the waves are backlit is also good. At low tide the bay side of the wayside is a good place for tide pools.

The Boiler Bay Wayside is also a good vantage point for watching gray whales during their winter and spring migrations.

Depoe Bay (55)

Despite its size, this tiny coastal town is renowned as the Whale Watching Capital of the Oregon Coast—and if that's what you want to do, plenty of charter companies in town will take you offshore to see whales. Depoe Bay's other claim to fame is as "the world's smallest harbor." The harbor is indeed very small, but it's also very photogenic, with one of Conde B. McCullough's bridges acting as its background.

Drive into Depoe Bay, and turn on Bay Street. Then turn right on Coast Guard Drive, into the harbor parking lot. Given the harbor's size, there are just a few locations for photography. I walk the sidewalk

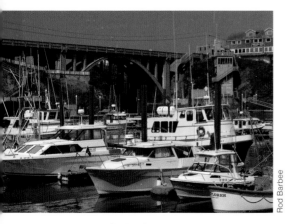

The harbor at Depoe Bay

that fronts the bulkhead and find a place where the boats and their masts make a pleasing composition with the bridge in the background. Access to the docks themselves is limited to "authorized personnel," but if you can find a friendly fisherman, you can get permission to go down on the docks. Mornings are best to photograph the harbor and the bridge.

If you're interested in **whale watching,** spring and summer are best. In summer the migrating gray whales come closer to shore to feed; in spring they're a little farther out. The whales are offshore in winter, as well—but considering the weather, they're the only ones who should be.

Cape Foulweather (56), Otter Crest Loop Road (57), and Rocky Creek Bridge Wayside (58)

When leaving Devil's Punchbowl (see #59), instead of following the signs back to Highway 101, turn left and drive the Otter Crest Loop Road. This road will lead you to **Cape Foulweather** and some fantastic views south to Devil's Punchbowl and Yaquina Head, the next headland and lighthouse to the south. Be sure to visit the **Lookout Gift Shop** perched atop Cape Foulweather. Besides postcards and souvenirs inside, you'll also find a great view looking north to more of Cape Foulweather. Unfortunately you'll have to shoot through the window because the best view, on the north side, is on private property.

Past the gift shop, Otter Crest Loop becomes one way—unfortunately going the wrong way if you want to head north. Follow signs back to Highway 101 northbound; once on 101, drive approximately 2 miles to the sign for **Otter Crest Loop Road.**

The first stop on the Otter Crest Loop Road, at 0.2 mile, is the **Rocky Creek Bridge Wayside.** Here are also informational plaques dedicated to Ben Jones, the father of Oregon's Coast Highway, and Conde B. McCullough, Oregon's master bridge builder. This is also a good spot for crashing waves on the rocks and pictures of the bridge. Late afternoon and sunset are the best times to photograph here.

Continue on Otter Crest Loop Road for more coastal views. About 1.25 miles from the Rocky Creek Bridge is a good viewpoint of Cape Foulweather and the Lookout Gift Shop. Another 0.1 mile gives you yet another great view of the Lookout and the ocean. Shortly after this lookout the Loop Road comes back to the gift shop and the beginning of the two-way road.

The Lookout at Cape Foulweather

Devil's Punchbowl State Park (59)

This small park is at the tip of the Otter Rock headland. At the parking area, peer over the fence into the collapsed roof of a sea cave. This is the punchbowl. Because the water churns inside the bowl during storms or high tides, it became the Devil's Punchbowl.

Late morning to early afternoon when the sun is high is the best time to photograph the punchbowl; otherwise, when the sun is low and the shadows are deep, there's too much contrast. On overcast days you won't have to worry about contrast, but the light won't be as nice.

Check tide tables, too; at high tide more water in the punchbowl will make for a more interesting picture. For the best shot you'll need a higher vantage point since the fence won't let you get close enough to the edge to view the entire punchbowl. If you have a tall tripod or a stepstool—anything to get you a little higher—your picture will be that much better for it. You'll also need a wide-angle lens to take in the whole thing.

If you want to go to a "secret" spot that most tourists don't know about, instead of walking to the punchbowl from the parking lot, walk down C Street two blocks to where it dead ends. A trail to the left leads down to a small beach on the north side of Otter Rock. From the beach turn left toward the head of Otter Rock.

Do this walk at low tide—the lower the better because the tide exposes wonderful rock shelves that are loaded with great **tide pools.** Be careful where you walk here so as not to kill any of the wondrous animals living within. At the end of the beach are two **caves** that can be walked into at low tide that lead to the bottom of the Devil's Punchbowl. Beware of sneaker waves and slippery seaweed. The rims of the caves make an interesting frame for scenics, and the tide pools are great foreground for coastal shots. Gull Rock lies offshore beyond the breaking waves.

Directions: Driving north from Newport or south from Depoe Bay, look for signs to

Devil's Punchbowl and Otter Rock. It's 8 miles from Newport to Otter Rock.

Moolack Beach (60)

Moolack Beach, which runs north from the northern side of Yaquina Head, looks like all the other wonderful Oregon Coast beaches, but this one has lots of photo potential. Access to the beach is easiest from the Moolack Beach turnout, about 3.5 miles north of Newport. From the beach below the turnout are excellent views of the Yaquina Head Light to the south and the long sweep of the beach to the north.

The lighthouse looks good early morning, late afternoon, at sunset, at twilight, and in fog—basically most of the time, regardless of the weather. Use a long lens to shoot just the end of Yaquina Head and the lighthouse or a shorter lens and include the breaking waves along the beach.

Yaquina Head Natural Area (61) and Yaquina Head Light (62)

Three miles north of Newport, Yaquina Head—a mile-long finger of rock—sticks into the Pacific Ocean. What used to be a rock quarry and a bare-bones lighthouse is now a state natural area with a nice interpretive center, a wildlife viewing area, and easily accessible tide pools. This is the first place I ever visited on the Oregon Coast years ago and where I first fell in love with the area.

The interpretive center, about halfway along the access road, is a good place to start your visit to **Yaquina Head Natural Area** and learn about the cultural and natural history of this diverse area. Your photography will always be better with increased knowledge of your subject—plus you can answer questions about your pictures when showing them.

The **Yaquina Head Light,** the tallest lighthouse on the Oregon Coast, is at the end of the access road. The lighthouse is open sporadically, despite its posted hours; hopefully you'll get the chance to climb to the top of it.

The best view of the lighthouse itself is from the back, at the eastern edge of the large parking lot. At sunset it's easy to get the lighthouse in front of the setting sun or to the side with the sun dropping over the horizon. You can also climb the hill behind the lighthouse and get a wider shot of the lighthouse and the ocean. The entire area is treeless, so you really have limitless photo options.

A large wooden viewing deck in front of the lighthouse looks out over the cliffs and a protective fence to a seabird nesting colony on top of a large rock just beyond the end of the headland. In the summer the rock is completely covered by nesting murres, gulls, and cormorants, and their cacophony is easily heard from the viewing platform. The seabirds are too far away for portraits, but it's possible to get nice groups of birds with long telephoto lenses. To photograph the nesting colony, the light is best in the morning.

There are closer opportunities to photograph seabirds on the point. On the north side are numerous small coves where guillimots and puffins nest. You're most likely to see guillimots (stubby black birds with red feet and white wing patches) than you are puffins (stubby black birds with colorful bills and yellow streamers over their eyes). Look for the puffins high on the cliff face under overhanging sod. Nesting or resting glaucous-winged and western gulls can be easily found on grassy ledges of the more gently sloping south side of the headland.

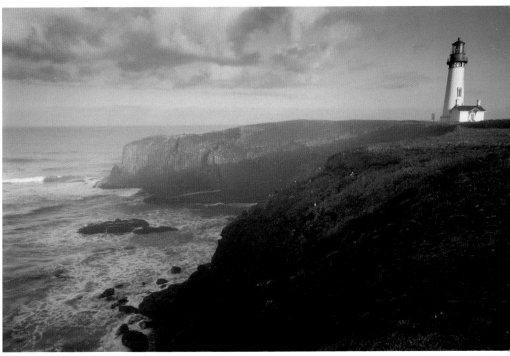

Rod Barbee

Yaquina Head Light

On the south side of the parking lot a long set of wooden steps leads down the cliffs to a small **cobble beach.** This very special beach has no sand, just beautifully rounded black basalt cobbles that ping with each rushing wave. The cumulative sound of all these pings is mesmerizing, but try to pull yourself away and notice how when wet, they make a great composition—especially with a sculpted piece of driftwood included.

At low tide, nice **tide pools** off the cobble beach are worth exploring. This area was wonderfully rich years ago, but it has become so popular with families and schoolchildren that much of the area is now pretty empty. Go when the tide is the lowest, and work the farthest-out pools. The more inaccessible the pools, the more likely that you'll find good things to shoot.

If beautiful cobbles and extensive tide pools aren't enough, how about dramatic seascapes? Lots of rocks just offshore make great subjects for breaking wave shots and foregrounds for broader scenics. The rocks to the south of the beach are a popular **seal haul-out.** You can't actually get to these rocks (which is why they're so popular with the seals), but you can get close enough at low tide to photograph them with a long telephoto lens.

Still not satisfied? Look up when you're on the beach, and you'll see the lighthouse at the top of the cliffs. This is a nice shot when the tide is in and water is at the base of the cliffs. From midmorning to midafternoon is the best time of the day for this composition.

You can climb back up the steps now. On your way back to the Coast High-

way, just before the fee booth is a junction with a short road on the left. This leads down to an old quarry site that is now a wheelchair-accessible tide pool area. A paved trail leads around this area, which has been seeded with tide pool critters. I've never had much luck here, but I always check it out.

Directions: The well-signed road to Yaquina Head is 3 miles north of Newport. There's a small fee for the natural area. The site is closed at night, so check the times to make sure you aren't locked in.

The Newport Area

Agate Beach (63) starts at the south end of Yaquina Head and runs for miles down to Newport. The easiest place to gain access to the beach is at the Agate Beach Wayside. Walk to the beach, and turn north toward Yaquina Head. There are nice views here of Yaquina Head Light over the waves along the beach. Morning is a good time for grand scenic photographs, but my favorite time is sunset. Pick a point on the beach where you can line up the lighthouse with the setting sun.

Directions: Agate Beach Wayside is about 2 miles north of Newport. Turn off the Coast Highway at the large signs.

The high-arching **Newport Bridge (64)** can be photographed from Yaquina Bay State Park, a relatively small bit of sand stuck between the North Jetty of the Yaquina Bay, the north end of the Newport Bridge, and the southern end of Nye Beach, which runs the length of Newport. It's also a good spot to photograph sunrise over the harbor. There's often fog in the morning, especially in late summer.

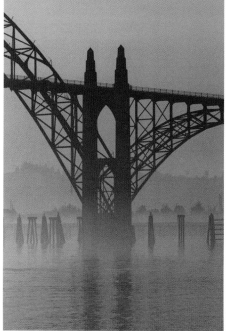

Rod Barbee

Yaquina Bay Bridge, Newport, at sunrise

The sun will rise right behind the Newport Bridge, and if it's foggy, the sun can be blood red. There's a good vantage point right at the beginning of the parking lot.

For an even better spot to photograph the bridge—and Newport Harbor—at sunrise, keep driving through the parking area, and park next to the jetty trailhead. Walk the trail to the grassy sand dunes, and make your way to the beginning of the jetty for great views.

You have a couple of choices here: get closer to the bridge so that it angles away from you, giving a "vanishing point" perspective. Use a wide-angle lens to get this effect. The other option is to walk farther out on the jetty to get more of a straight-on view. Whichever you choose, think about where you want the sun to be in relation to the bridge. You have several choices here, too.

Besides the wide-angle shots, be sure

to pull out a telephoto lens; 80–200mm or 300mm should do. Pick out details of the bridge in the fog. Also look for fishing boats heading out to sea. If you photograph the outgoing boats, time your shots so that you avoid merging parts of the boats with pylons and other stuff in the bay. And use a fast enough shutter speed to stop their motion.

The **Yaquina Bay Light (65)** is a small lighthouse that was supposed to be located north on Cape Foulweather but was built here instead. It's only open and accessible from 11 AM to 5 PM, but this doesn't mean you can't photograph it. Paved trails circle the lighthouse through the picnic area and good viewpoints.

The best view for sunrise is probably on the "back" side of the lighthouse—the side facing east. Walk the trail to a large access gate for service vehicles. Though you'll be unable to get a full lighthouse shot due to the fence, the signs, and other distractions, you'll easily be able to isolate the lighthouse tower with an 80–200mm or 70–300mm lens. Early-morning light on the lighthouse works well. It would look even better with clouds or fog behind it! For sunset, just move to the other side, and photograph from the parking area using the same strategy and lens.

Directions: From Highway 101 in Newport, coming either from the north or south, look for the sign to Yaquina Bay State Park at the north end of the bridge. The road curves around and ends at the lighthouse parking lot.

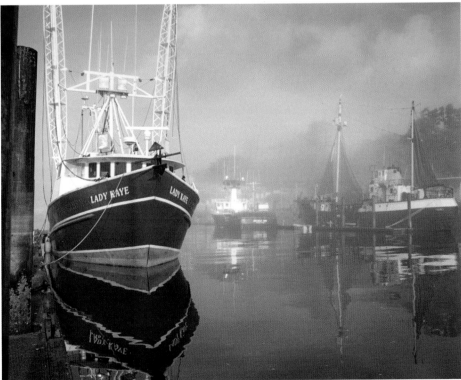

Scott Bourne

Newport Harbor

If you like traditional harbors with lots of working boats and piles and piles of fishing gear, **Newport Harbor (66)** is worth exploring. The best part of the harbor is on Bay Boulevard on the north side of the Yaquina Bay inland from the Old Town part of Newport. This is where the processing plants are located and where the boats unload their catches and tie up for the night at the docks. You can walk the docks if you don't get in the way, but don't make a nuisance of yourself—these are working boats with working people trying to earn a living.

The parking area for the fishing boats usually has piles of colorful nets, ropes, buoys, and crab pots. These make terrific subjects for their wonderful textures and bright colors. Zoom in and fill your frame with nothing but gear. There are more fishing-related subjects farther up the bay, including more piles of gear, old beached boats, and pilings and piers for larger boats to tie up to. There are also lots of birds to point a long lens at: great blue herons, cormorants, ospreys, sandpipers, ducks, gulls, and even bald eagles. The road eventually ends at a huge lumber mill in Toledo at the head of the bay.

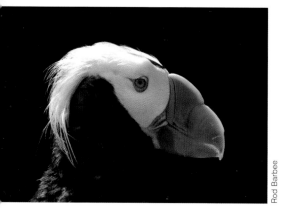

Tufted puffin at Oregon Coast Aquarium

Rod Barbee

Directions: On the south end of town by the northern end of the Newport Bridge, turn on just about any of the roads heading inland. These all curve downhill and end up on Bay Boulevard and the touristy Old Town area. The docks start at the east edge of Old Town.

The south side of the harbor is where the pleasure-boats reside . Instead of turning toward the bay, turn instead toward the ocean and the **South Jetty (67)** area. You can drive all the way out to the beginning of the south jetty along the edge of the Yaquina channel, which leads under the bridge between the ocean and the harbor. The shore of the channel is a good place to find resting ducks and gulls, especially in winter. It's also a great place to photograph the comings and goings of boats and ships.

South Beach (68) starts at the South Jetty and extends southward for miles. There is a state park with a nice campground, but the star attraction is the big empty beach with row after row of curling breakers. Take a walk along the beach, concentrating especially on the back beach area, where there are often interesting photographic subjects like driftwood and abstract patterns in the sand.

The star of the south shore of Yaquina Bay is the **Oregon Coast Aquarium (69).** This magical place offers lots of wondrous things to see and some even to photograph. The best opportunities are in the outdoor aviary, where it's possible to get frame-filling shots of puffins, oystercatchers, guillemots, and murres with short zoom lenses. Or take nice pictures of sea otters and seals and, with a bit of patience, the anemones and other bizarre looking critters inside behind glass. Be sure to

gaze into the moon jellyfish tank. It isn't possible to photograph the jellies, but they sure are mesmerizing.

Directions: The aquarium is on the south side of Yaquina Bay. Turn east just before the southern end of the Newport Bridge at the well-signed intersection.

South of Newport

Drift Creek Wilderness (70)

Old-growth forests have been virtually all logged out of the coastal range, so any remaining tracts are very rare and very valuable. Coastal old-growth is magnificent: trees 5 to 6 feet thick, moss-draped limbs, and soft ground sprinkled with delicate wildflowers. It is an awe-inducing, magical cathedral that doesn't exist anywhere else in the world.

The Drift Creek Wilderness is one of the last places where old-growth can still be found and enjoyed without too much exertion. While most of the wilderness area is steep and inaccessible, the first part of the trail along Horse Creek Ridge is pretty flat and great for photography. The forest here is comprised of very ancient 5-foot diameter hemlocks with a sprinkling of huge Douglas firs and Sitka spruces. In May the forest floor is dotted with white trilliums and pink bleeding hearts, and everything seems to glow.

The trail slopes very gradually downhill for the first 2 miles, so linger along this part unless you want to really hike all the way down to Drift Creek. Beautiful scenes are plentiful along the beginning part of the trail, so enjoy that section for photography.

Directions: Go north 7 miles from Waldport on Highway 101 to Ona Beach State Park; turn right on North Beaver Creek Road for 1 mile to a fork. Veer left for 2.7 miles to a T, and turn right onto North Elkhorn Road for 5.8 miles. At another T, turn left onto Road 50 for 1.4 miles. Then take the right fork onto Road 5087 for 3.4 miles to the trailhead. The Horse Creek Trail starts by the registration booth.

Seal Rock State Park (71)

One of the best places to go tide pooling on the coast is at the Seal Rock area accessible from the Seal Rock Wayside. Take the short trail down to the north end of the beach, and work your way down the beach and the rocks. At low tide lots of pools in the rocks are full of anemones and sea stars. At the lowest tides you can walk out to the small sheltering islands that protect the beach and the more remote tide pools, but be careful of sneaker waves breaking over the lower rocks.

Even at other tides there are lots of things to photograph at Seal Rock. At midtide the water-sculpted beach rocks have little pools connected by tiny rills that are great foregrounds for scenic shots of the bigger, ocean rocks. At higher tides the beach is a great spot to photograph breaking waves crashing over farther small islands. At sunset, walk the beach to line up the setting sun between the islands.

Directions: The Seal Rock Wayside is about 10 miles south of Newport and about 6 miles north of Waldport. The wayside is just south of the tiny hamlet of Seal Rock on the Coast Highway.

Recommendations: If you can't just move here and spend the rest of your time on Earth photographing this part of the coast, spend as much time as you can

here. When it's lightly raining, misty, or foggy, head directly to the Drift Creek old-growth forest for a taste of magic. Don't go there if it's at all sunny. Too much contrast destroys all forest pictures.

If it's a sunny day, go to the harbor and work on reflections of the fishing boats, or head to the aquarium and play with the puffins. If it's an awful day to photograph or if you're simply not in the mood, go to the aquarium, anyway; you won't regret it.

You can go anywhere and get good shots on foggy days. Start at the harbor, and take pictures of the fishing boats looming in the fog, and then run up to Depoe Bay and play with the harbor there. Then go over to Moolack Beach and photograph Yaquina Head and the lighthouse coming out of the fog. Then take a nap.

Pro Tips: When visiting tide pools, the questions always are: When do I visit? And where do I go to find the best stuff? Buy a local newspaper and check the tide tables. Then pick the day with the lowest number indicating the lowest tide. If I have a choice, I like blue-sky days for scenics or rainy days for close-ups.

Once at the tidal areas, walk as far from the access point as you can to avoid the heavily used (and abused) areas. Either go farther down the beach to more distant tide pools or farther out to the edge of the low-tide areas. The best critters will be in the deepest and least visited areas.

When setting up a composition, you'll have to decide if you want to include people (or bicycles or cars or boats, etc.) in your shot. This should be a deliberate decision, not just happenstance. If you opt for people, wait for the most photogenic folks, and shift around to put them in the best position. If you're including moving things like boats, wait until they're in the position you want them to be. People can sometimes be cooperative and work with you, but boats will never be, so plan ahead. Whatever you do, avoid merging the people and boats with other things in your picture, and use a fast enough shutter speed to stop the motion.

For great images try this fun and effective compositional technique. On a gray and moody day on the seashore, make it even moodier by using a polarizer, a neutral-density filter (not a graduated ND), and f/22 to slow your shutter speed down as much as you can. It helps if you use very slow film, as well. Try to get your shutter speed to 1 second or less. Then compose with the breaking waves prominently in your composition. The slow shutter speed will blur the waves and give them a cotton-candy-looking effect. You may need to wait until it's closer to sunset when the light is less to get the desired shutter speed.

Cautions: I know this is getting redundant, but be careful anytime you're around breaking waves. Not all waves are created equal; it's those unusually large ones that can sneak up on you and drench you and your gear—not to mention carry you out to sea. None of these are good things.

When photographing on a beach, be extra careful about blowing sand. This is especially true for digital cameras. Never leave your camera open, and never leave the body caps or lens caps off your camera and lenses. Same is true with salt spray. Protect all your gear, including tripods, from blowing salt as best you can, and rinse off your exposed gear with fresh water as soon as you can.

V. Florence Area

General Description: If the Oregon coast is a playground, then the Florence area is its sandbox; no other region on the entire West Coast has as large an area of sand dunes. In addition to the allure of the dunes, the area also has the most photographed lighthouse on the West Coast, some wonderful trails through old-growth forests, and more blooming rhododendrons than you can imagine.

Directions: Florence is at the junction of Route 126 and the Coast Highway. Route 126 is a direct route to Eugene in the Willamette Valley and the best way to get to the midcoast from Interstate 5.

Specifically: The dunes around Florence are photogenic in any season, but in May and June when the rhododendrons bloom in the sand, they become truly spectacular. Up the coast, Heceta Head Light deserves every accolade it has ever received; the view of it from the south is one of the best on the coast. Nearby are the Sea Lion Caves, where hundreds of sea lions come to rest in the winter. Inland are several nice walks into pretty old-growth forests.

> **Where:** Midcoast about half way between Newport and Coos Bay
>
> **Noted for:** Rhododendrons, dunes, harbors, lighthouse, tide pools, beaches
>
> **Best Time:** Late May
>
> **Exertion:** Minimal to moderate hiking
>
> **Peak Times:** Spring: late May; summer: late June; fall: mid-October; winter: December
>
> **Facilities:** At developed sites
>
> **Parking:** In lots
>
> **Sleeps and Eats:** Many in Florence, some in Yachats
>
> **Sites Included:** Yachats, Smelt Sands Recreation Site, Yachats River Covered Bridge, Yachats River Waterfalls, Cape Perpetua, Cooks Ridge Trail, Gwynn Creek Trail, Strawberry Hill Wayside Seal Viewing area, Heceta Head Light, Devil's Elbow State Park, Heceta Head Light Viewpoint, Sea Lion Caves, Darlingtonia State Wayside, Old Town Florence, Gallagher's Park, Jesse Honeyman State Park, Canary Road, Oregon Dunes Overlook, Tahkenitch Creek, Sweet Creek and Sweet Creek Falls, Beaver Creek Falls

North of Florence

Yachats (72)

Yachats (pronounced Yah-hots), a charming little resort about halfway between Newport and Florence, is a great place to photograph crashing waves or for taking a walk on the beach. It's also one of my very favorite places on the coast to just hang out. The best time to visit? Anytime.

The sandy and rocky coast of Yachats can be reached two ways. One is to turn onto the Yachats Beach Access Road, which intersects the Coast Highway on the south side of the bridge spanning the Yachats River and leads down to the sandy beach at the mouth of the river. Drive a short way, and you'll also see plenty of opportunities for crashing-wave photos with the town in the background.

The other route is to drive into the **Smelt Sands State Recreation Site (73)**

immediately north of town off Lemwick Lane. Access the beach from the parking area at the end of the road, or walk a trail north along the coast to more rocks and small beaches.

At both locations there are nice tide pools at low tide and often crashing waves that blow high into the sky at high tide, especially after a storm. No one else knows about these beaches but the locals, so you should have the area mostly to yourself.

Yachats River Covered Bridge (74)

Since you're in the neighborhood, how about visiting a covered bridge? This small, photogenic bridge spans the Yachats River and is surrounded by a pretty forest of alders and spruce. The best, and maybe only, place to photograph the bridge is from the north side. Park in the pullout before the bridge, and then walk across the bridge to where the asphalt ends, on the east side (your right side with the bridge to your back).

Here, with a lens in the 28–70mm zoom range, you'll be able to get a nice shot with blackberry bushes in the foreground and a huge spruce in the background. Also take a peek at the river below the bridge. Depending on the time of year you're visiting, you could find some nice stream shots.

Autumn would be a great time to visit, when the leaves on the surrounding alder trees will turn yellow. During spring and early summer you'll have the bright greens of new growth.

Directions: Drive the Yachats River Road (look for the sign just north of the Yachats River Bridge) for 7 miles until you come to a T. Turn left onto North Fork Yachats River Road for another 1.4 miles to the

Rod Barbee

North Fork Yachats River covered bridge

covered bridge and the end of the road. Park either in the pullout before the bridge or a larger area on the other side of the bridge.

Yachats River Waterfalls (75)

This waterfall can be found in what the locals say is an old rock quarry and is now a nice stand of alder, hemlock, and spruce plus plenty of blackberry bushes. The ground can be muddy here, even in late summer, so be sure to wear boots.

On the Yachats River Road, drive 0.4 miles past the Mile Marker 1 sign. You'll see a large pullout. Park here, and walk the road back toward Yachats for about 100 yards. On your right you'll see what appears to be a driveway. This quickly turns into a trail that almost immediately splits. Take the left-hand trail, and you'll shortly come to a 20–30-foot waterfall. On an overcast day, in soft light, this is a nice little scene.

David Middleton

Mossy spruce

If you go right, the trail climbs slightly and soon comes to a small campsite. Keep to the left, following a faint trail, and work your way to the back of the old quarry. You'll soon hear the second waterfall, and then you'll see it. This waterfall isn't as accessible as the first one, but it is as pretty.

Cape Perpetua (76)

This 2,700-acre Forest Service Scenic Area is a great place for photographers to spend a couple of hours or a couple of days. Cape Perpetua offers more than 20 miles of hiking trails, a magnificent rocky coastline, a spectacular view 800 feet above the ocean that you can drive to, an interesting visitors center, and easy access to the coastal rainforest. Many sites are worth exploring.

From the main parking area, follow the trail down hill marked SPOUTING HORN. At the junction turn left, and you'll shortly be at the Spouting Horn, so named because when incoming surf enters a small cave, it "spouts" out the top, sometimes more than 30 feet. This is also a good spot for crashing waves, plus there are nice tide pools here at low tide.

If you turn right at the junction, you'll come to a trail that leads down a short ways to the Devil's Churn, a narrow inlet where the surf pounds and the crashing waves can be spectacular. (You can also get there by driving to the Devil's Churn Wayside on the Coast Highway.) The churn can be photographed from the trail, or you can walk down onto the rocks for a better angle. Be careful; the waves can splash pretty high, and you could easily be covered with a salt-water mist. (And if this isn't enough stimulation for you, this being Oregon, there's an espresso stand at the Devil's Churn Wayside.)

You can do a number of hikes at Cape Perpetua. One of my favorites is the easy walk to the **giant spruce** along Cape Creek. The creek is tiny, and most of the forest is second-growth alder and Douglas fir, but it's one of the best places on the coast to photograph wildflowers in April,

May, and June. And a huge Sitka spruce at the end of the mile long trail is, well, huge.

Another great hike requires considerably more effort but also gives considerably more rewards. The **Cooks Ridge Trail (77)** starts at the back side of the visitors lot at Cape Perpetua and follows an old road gradually uphill. In about 0.75 mile you reach the top of the ridge and enter one of the nicest old-growth forests on the entire coast. For the next 2 miles the mostly level trail wanders through a forest of mossy-branched giant spruce and a forest floor thick with moss, downed logs, and pretty wildflowers.

The Cooks Ridge trail eventually leads to a junction with the **Gwynn Creek Trail (78),** 2.3 miles from the parking area. At this point you can decide to retrace your route back along the ridge, or continue down into the secluded valley to the north. This trail eventually turns west and intersects the Oregon Coast Trail a mile south of the Cape Perpetua parking area.

Directions: Cape Perpetua Scenic Area is 3 miles south of Yachats and 23 miles north of Florence.

Strawberry Hill Wayside Seal Viewing Area (79)

Two miles south of the Cape Perpetua visitors center is a group of close offshore rocks frequented by harbor seals. Amazingly, they are tolerant of humans, so this is the best place on the coast to photograph seals. The best time to visit Strawberry Hill is on calm days at low tide, conditions that let you get close to the seals without the risk of being soaked by a breaking wave.

The seals can be here any time of the year, but they are most numerous in summer. A moat prevents people from walking on the seals' haul-out rocks, but if you

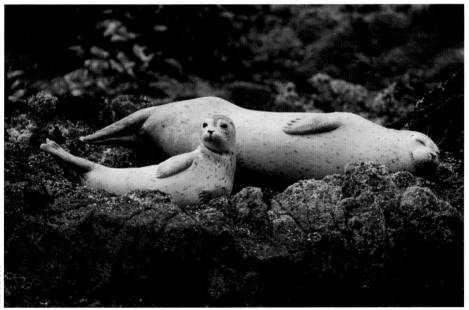

Rod Barbee

Mother and pup harbor seals

are loud and disrespectful, you'll still disturb the seals. It is illegal to bother them in any way, so use a long telephoto, and let the seals rest and swim in peace.

Be extra careful carrying a big, heavy lens down to the rocks. The footing is difficult and can be slippery. Also pay attention to the tide. It'd be easy to get cut off from the parking area if you let yourself get too caught up in the seals.

Directions: The well-signed Strawberry Hill Wayside is 2 miles south of Cape Perpetua, with picnic tables and interpretive signs.

Heceta Head Light (80) and Devil's Elbow State Park (81)

It has been written many times that **Heceta Head Light** is the most photographed lighthouse on the entire West Coast. This is because you can get a magnificent shot right out your car window of the overall setting of the lighthouse on its rocky promontory, and with just a bit of walking you can also get some great shots right at the lighthouse.

From the parking lot, follow the easy 0.5-mile trail to the lighthouse itself. The trail passes by Heceta House, the historic assistant lightkeeper's house, built in 1893 and now available as a vacation rental. This building has some photographic possibilities using wide-angle lenses and the fence as a leading line. Continue on to the lighthouse.

A great shot can be made from the north side of the lighthouse. You'll notice a spot where the railing is rather low, and a "trail" leads up behind the lighthouse. Climb the trail for great views to the south, with the lighthouse in your foreground. Watch for mergers with railings

on the lighthouse and points on the headlands in the distance. Try timing your shots to coincide with the light, which is on a 10-second interval.

Use wide-angle lenses to include the entire lighthouse (part of it will be blocked by the nearby trees) or a normal lens to isolate the top of the light, using the coastline and sky as background. The shot from behind the lighthouse is best at sunset, especially with colorful clouds in the background.

Be careful climbing to vantage points behind the lighthouse. This is not a maintained trail but rather an unofficial way trail used by photographers and other folks looking for a unique viewpoint. It's steep without handrails or other safety barriers. It's even more dangerous if it's windy.

Other subjects besides the lighthouse include the beach at **Devil's Elbow State Park (81),** adjacent to the parking lot, which is a good sunset location. And from the beach there's a good view of Cape Creek Bridge, another of Conde B. McCullough's designs.

Heceta Head Light Viewpoint (82)

A mile south of the Heceta Head Light parking area, a large pullout on the Coast Highway has one of the best views along the coast. As soon as you see the view, you'll realize why this is the classic spot to photograph the Heceta Head Light. A short telephoto works well here. Best light, of course, will be late afternoon to sunset, but you can also make nice images early to midmorning, before the atmosphere gets hazy.

And this is one of the better places on the coast to spot gray whales during their winter and spring migrations.

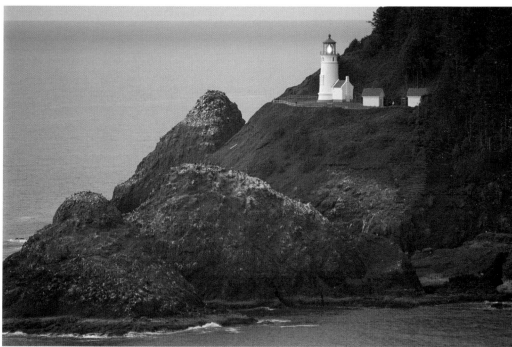

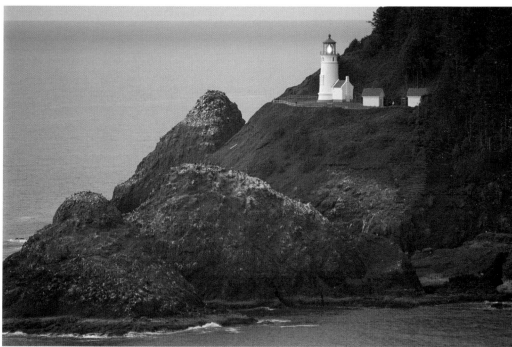

Rod Barbee

Heceta Head Light from Highway 101

Sea Lion Caves (83)

Sea Lion Caves is a sea cave that both Steller's and California sea lions use as a resting area. Initially Sea Lion Caves looks like a hideous tourist trap—and it is. But this is one tourist trap worth getting snared in.

Enter the gift shop, and pay your entrance fee. The attendant will tell you where the Sea Lions are to be seen that day; either from an outdoor platform, looking down on the haul-out point, or from inside the cave itself.

If the sea lions are at the haul out, photograph them from the platform using a long lens—at least 300mm but preferably 500mm or longer. This is a good spot to observe and photograph seal lion behavior, albeit from an aerial view.

The cave itself is well worth the price of admission. Discovered in 1880 by a local seaman named William Cox, this cave is said to be the largest in the world. An elevator drops over 200 feet and lets you out in the dimly lit cave. It's truly impressive, and anybody interested in nature or nature photography ought to visit. The ceiling rises dozens of feet above your head, and the air is full of the sounds of surf and sea birds as well as the smell of the sea (and any sea lions in residence).

The owners of Sea Lion Caves have done a wonderful job with the interpretive displays, including one of a bull sea lion skeleton preserved in the sandstone floor of the cave.

You won't be able to photograph sea lions from the cave itself; it's just too dark, and flash isn't allowed. At the southernmost part of the cave that's accessible to

people, a chain-link fence has been erected. A hole in the fence here is big enough for camera lenses.

The large cavern where the sea lions reside can be photographed as a landscape using a wide-angle lens. A 28–70mm zoom is perfect. You'll need a long exposure, though, so be sure to bring a tripod, or use very fast film or a high ISO setting on your digital camera.

The north end of the cave opens to a great view of the Heceta Head Light. Waves crashing in the foreground with the lighthouse in the background make for a different picture of Heceta Head than you'd normally see. An 80–200mm zoom would work well here. A railing at the opening has room for about four people—or two tripods. If you want to photograph from here, you'll need to exercise some patience and share the space with other visitors.

Directions: The caves are located 1 mile south of Heceta Head Light. Admission is $7; open daily 9 AM to 6 PM.

Darlingtonia State Wayside (84)

This wayside is a unique area full of the rare carnivorous California pitcher plants, a.k.a. cobra lilies *(Darlingtonia californica)*. A short trail leads to a boardwalk in a small swampy area. You won't be able to get down next to the plants since you need to stay on the boardwalk, but you'll nevertheless be able to photograph these unique plants.

Spring and early summer are the best times to photograph, though you'll also be able to view them in the late summer. If possible, photograph in overcast or during a light drizzle because unless you can find a good specimen close to the board-walk, you won't be able to get close

enough to use your diffuser. You'll need at least a 200mm macro lens to get frame-filling shots.

Directions: About 1.5 miles north of Florence and about 7 miles south of Heceta Head Light, look for the sign for the Darlingtonia State Wayside on Mercer Lake Road. Turn east on Mercer Lake Road; Darlingtonia Wayside will be on the south side of the road. Rest rooms are available, and there are interpretive signs on the boardwalk.

Florence Area

Old Town Florence (85) on the Siuslaw River is the restored waterfront part of the town of Florence. It's a great place to wander around with a camera, snapping photos of the picturesque storefronts, the 60 historic buildings, the waterfront, and even a stern-wheeler. Be sure to visit the harbor on the east side of Old Town. This is a good place in both early and late light for pictures of the river and waterfront.

Early in the morning, park next to Catch the Wind kite store and stroll to the river for a great view of the Siuslaw River Bridge, another of Conde B. McCullough's masterworks. A lens in the 28–70 mm range works well here, but you also may want something wider if you find some interesting foreground subjects to work with.

For a more aerial view of Old Town, walk across the bridge. The south side will give you the best overall views. Wait until midmorning so that Old Town will be well lit. The sun comes up farther to the south in spring and autumn, which might put a slightly better light into the town.

An excellent morning location for a panoramic image of the entire town and

the bridge can be found by driving to the south side of the bridge and taking a left (after the Best Western) on Glenada Street. Drive to the bottom of the hill opposite Maple Street to the Pritchard Wayside.

Directions: Old Town is on the north side of the Siuslaw River, due east of the Siuslaw River Bridge. Most of the town is along Bay Street.

Also right in the town of Florence is **Gallagher's Park (86),** well worth a visit because it is full of rhododendrons and azaleas. Something is always in flower here, but peak time is May and June when the rhododendrons and azaleas are in full bloom. The park isn't very big, so it won't take you long to look around. You'll need a wide-angle lens for some of the larger specimens and some close-up gear for the flowers themselves.

Directions: Follow Highway 126 as if you were heading out of town. At Spruce Street (just a couple of blocks from 101), turn left and park. Gallagher Park is on the corner of Highway 126 and Spruce.

South of Florence

Florence is renowned for one thing, the **Oregon Dunes National Recreation Area,** a 47- mile stretch of sand dunes extending from Florence to Coos Bay. While much of the area is open to dune buggies and it can be packed in the summer, there are still lots of places to find stunning pictures.

Jesse Honeyman State Park (87) is the most popular park for tourists coming to the area. The dunes in this park lie within the off-road vehicle (ORV) usage area, so if it's pristine dunes you're af-

Part of Old Town Florence

ter, you're better off in either Umpqua Dunes or at the Oregon Dunes Overlook/ Tahkenitch Dunes area. Even so, there are some images to be had.

From the large day-use parking lot at Cleawox Lake, climb the dunes, and work your way toward an island of trees in the dunes. From this tree island you'll have a good view of Cleawox Lake, its fishing pier, and probably lots of swimmers (if you're here in summer). It's about 2 miles to the ocean from this tree island.

If you continue toward the ocean from this vantage point, you'll be in the busiest part of the ORV area, and you won't be a happy photographer. Instead, head south, paralleling the ocean to find a less disturbed part of the park. About a mile from Cleawox Lake is a very tall dune with a great view from its top. This dune is due west of the park campground.

In April, May, and June, the rhododendrons are in bloom. In fact, the Rhododendron Festival in Florence happens every year during the third weekend in May. There should be ample opportunities for photographing rhodies in the fog, rhodies along trails, rhodies reflected in lakes, and rhodies in sand.

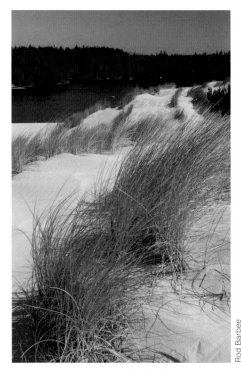

Honeyman State Park, Florence

Rod Barbee

Directions: Jesse Honeyman State Park is 3 miles south of Florence on the Coast Highway.

Directly across Highway 101 from the Honeyman State Park entrance is **Canary Road (88).** The roadway crosses three bridges spanning Woahink Lake, so you have numerous reflection possibilities here and at the day-use areas accessible from Canary Road. You'll need to be aware of man-made objects such as floats that could sneak their way into your pictures. Best times are in the morning when the light is soft—even better if there's some fog or mist.

Approximately 7.5 miles south of Honeyman State Park is the **Oregon Dunes Overlook (89).** This is one of the areas where you can get photos of sand

dunes without ORV tracks crisscrossing your frame. Some pretty good vantage points are right from the viewing platforms, but for more options you'll want to follow the trail into the dunes.

For the best-looking dunes, you'll need to get out there early on a morning following a windy night, before the rest of the hikers show up. Also, early morning is when you'll get the nice low side lighting, which will bring out the details in the dunes. This also happens late afternoon, so the dunes can make a good sunset subject.

The trail leads about 1 mile to the beach, and you can also follow a loop trail for about 3.5 miles to the Tahkenitch Creek trailhead. Frankly, you'll probably find something "duney" to photograph rather quickly without having to slog through miles of sand with heavy photo equipment.

Tahkenitch Creek (90) is about 1.5 miles south of the Oregon Dunes Overlook turn-off (approximately 9 miles north of Reedsport). A short hike from the trailhead will bring you to the creek. This is another spot for ORV-trackless dunes. Keep hiking the trail, and you'll come to several spots with creek access. Try using the creek as a graphic element in your pictures. Look especially for S-curves in the creek and dunes and for reflections.

Sweet Creek and Sweet Creek Falls (91)

Living up to its name, Sweet Creek is very sweet for photographers. From Florence, drive east on Highway 126 to Mapleton. Immediately after crossing the bridge in Mapleton, turn right onto Sweet Creek Road. Follow the road for 10.2 miles through some beautiful country to the

Homestead trailhead parking. According to a local tourism guide, elk are often seen in the fields adjacent to the road.

The trail to the falls is only 1 mile long, but you may never make it, there's so much to photograph. The trail follows the stream through a canyon, and along the way you'll see many small, tiered falls and a few larger punchbowl falls. Some places are easily accessed by short side trails; others will require a bit of a scramble.

Depending on the time of year and water levels, you'll be able to get right in front of some of these small falls, using them to great effect as foreground features. Use a wide-angle lens in the 17–28mm range. You may need to get right out in the water for some shots. The solid rock streambed can be very slippery in places, so be very careful. One particularly nice area where the stream is wide and tiered with two short falls is adjacent to a place on the trail with an interpretive sign about a nurse log.

Gallon for gallon, this stream is one of the very best along the coast for nature photographers. The trail itself is easy to hike and well maintained, and catwalks are bolted to cliff walls in places where a trail would be impossible. This site is especially good in spring and early summer, with all the new foliage and more water in the falls. Late summer and autumn are also good: Lower water levels in late summer make it easier to get out into the streams, and in autumn the maples lining the stream will add a touch of color to your compositions.

Sweet Creek Falls is very popular with swimmers, so photographing the falls in summer may require patience. Fortunately, most people swim on hot, sunny days, which aren't the best for waterfall photography. If you're there in the best photographic conditions, there should be very few people.

Beaver Creek Falls (92)

If you didn't get enough of Sweet Creek during the canyon hike to the falls, there is more to be had. Drive up the road 1.3 miles, and park at the pullout. Here a 0.6-mile continuation of the Sweet Creek Trail leads to Beaver Creek Falls.

If you drive just past the trailhead, here a road leads about 0.5 mile to the top of Beaver Creek falls. Hike a short (0.1 mile) trail to a railed viewpoint of the falls. It's possible to scramble down to the base of the falls, or you can photograph portions of the falls from this viewpoint and the immediate area. Use a moderate telephoto, like an 80–200mm zoom, to isolate portions of the falls.

Recommendations: First linger in Yachats. Put your camera away, and just enjoy this little town, which is a great place to be based for a photo trip. Second, wander on a beach. Put your camera away, and keep your feet moving. The process will clear your brain and improve your photography. Trust me.

If you wake up and it's rainy, head to Cape Perpetua and wander in the magnificent forests, or go to Sweet Creek and play with the stream and waterfall. If it clears up, go explore the dunes or a piece of the rocky coast. If it turns into a screaming blue sky day (aren't you lucky!), play with reflections in the many lakes hidden in the dunes. If it's foggy and late spring, first pinch yourself to see if you haven't died and gone to heaven. Then head either to the forest or to blooming rhododendrons, and do portraits of the blossoms or wider shots of pink hillsides.

Spend every single late afternoon, sunset, and twilight at Heceta Head Light. I don't care what the weather is; go there, and hang out and see what develops. And don't leave as soon as the sunset fades. Twilight is my favorite time to photograph the lighthouse.

Pro Tips: No matter how small the site or how narrow your photography interests, there is never a time when there's just one shot to take. Once you get the obvious image out of your system, grab another lens and find another shot to take, then another.

This is especially true at the Heceta Head Light pullout. There are several very strong compositions here, but the tendency is to be satisfied with just one. In large part your composition will depend on what's going on in the sky. If you've got a bald, blue sky, eliminate as much of it as you can by either zooming in on the lighthouse or using waves and the shape of the coastline as a foreground. If you've got big puffy white clouds, storm clouds, clouds lit up at sunset, any clouds at all, place the lighthouse toward the bottom of the frame, and put that great sky to some use.

When taking pictures of lighthouses, time your shots with the beacon flashes. This beacon is the same as getting a catch light in an animal's eye: It animates the lighthouse as an animal is animated.

Cautions: The two main concerns here: rocks and sand. Rocks are slippery, especially at low tide when seaweed seems like a good place to step but it's a better place to slip. Plus rocks usually have waves around them. As soon as you think you have the timing of the waves figured out, one will surprise you and soak you and your gear.

Calypso orchids

David Middleton

The only physical caution concerning sand is that it's a real bear to hike through, especially with the extra weight of photo gear. A mile walk in sand very quickly seems like a 10-mile slog. Sand dunes also have a way of all looking the same, so bring a compass, or keep your wits about you so that you don't get lost and spend 40 days and 40 nights wandering in the dunes.

But sand can be your camera's worst enemy. Simply dropping a lens in the sand can cost you hundreds of dollars in cleaning costs. Be extra careful if the wind is blowing. In fact, give second thoughts to pulling out gear in blowing sand. At the very least, use a protective filter for your lens, and when you change film, do it in a sheltered place, either inside a garbage bag or inside your jacket with your back turned to the wind. Just be cautious.

VI. Coos Bay to Bandon

SPRING ★★★ SUMMER ★★★★ FALL ★★★ WINTER ★★

General Description: This is the working part of the Oregon coast—at least it was until recently. Evidence of huge log mills, now mostly empty, and scarred hillsides, now mostly covered in new growth, is obvious. But if you hug the coast and keep your eyes seaward, you'll find beautiful locations to photograph.

Directions: The Coast Highway is the main route here, although it doesn't hug the coast as much as it does up north. Coos Bay is the hub, accessed by Route 42 through the Coast Range from Roseburg on Interstate 5.

Specifically: The Coast Highway takes a roundabout route in this part of the coast, passing well inland of Cape Arago as it scoots around Coos Bay before returning to the coast at Bandon. This means that the entire Cape Arago area is mostly ignored and very worth a visit. Bandon is a photographer's dream, with what I think is the prettiest beach on the entire coast.

> **Where:** Southern part of the coast, opposite Roseberg on Interstate 5
> **Noted for:** Dunes, harbors, lighthouse, tide pools, beaches, forest hikes
> **Best Time:** Late May
> **Exertion:** Minimal to moderate hiking
> **Peak Times:** Spring: May; summer: late June; fall: mid-October; winter: December
> **Facilities:** At developed sites
> **Parking:** In lots
> **Sleeps and Eats:** In Coos Bay, Bandon, Reedsport, and North Bend
> **Sites Included:** Umpqua Dunes, Umpqua River Light, Dean Creek Elk Viewing Area, Coos Bay, Coos Bay Bridge, The *New Carrisa* Shipwreck, Charleston Harbor, South Slough National Estuarine Reserve, Sunset Bay State Park, Cape Arago Light Viewpoint, Shore Acres State Park, Simpson Beach, Simpson Reef Viewpoint, Cape Arago State Park, Old Town Bandon, South Jetty Park, Bullards Beach State Park, Coquille River Light, Coquille Point, Sunset Motel, Face Rock Wayside, Bandon State Park

North of Coos Bay

Umpqua Dunes (93)

Located about 5 miles south of the Umpqua River Light turnoff, the Umpqua Dunes are a good place to go for pristine dune photos. It's about a 0.5-mile walk through the Eel Creek Campground to the dunes. Once you reach the dunes, there are lots of things to photograph. If you like struggling through sand, though, explore past this point. The farther you go into the dunes, the more likely your pictures will be different than everyone else's because most people don't expend the energy needed to get back there. Early morning, late afternoon, and sunset are the best photography times; the low light will help bring out the details in the sand.

Umpqua River Light (94)

Standing among maintenance and residential buildings and surrounded by a fence and signs, this lighthouse is difficult to photograph without including lots of

not-so-pretty stuff. Nevertheless, a few tricks can help at least get something. Try photographing just the upper part of the lighthouse using an 80–200mm zoom, or go down to the sand dunes below the lighthouse and photograph up toward the light. From the beach you'll be able to eliminate the other buildings, though you'll also have to cut off the very bottom of the lighthouse.

Directions: From the north, turn west off Highway 101 about 1 mile south of Winchester Bay onto Lighthouse Road. Follow the road to the lighthouse. From the south turn west (left) approximately 4.5 miles north of Lakeside.

Dean Creek Elk Viewing Area (95)

Dean Creek is a small tributary of the Umpqua River. Where they join, in a mix of meadows and forests, a herd of Roosevelt Elk can be seen year-round. This is an Oregon State Fish and Wildlife area, so viewing is tightly controlled, but it's still the best place to see wild elk on this part of the coast. The viewing area extends along Highway 38 for about 3 miles, with plenty of turnouts stopping.

In addition to the 100 or more Roosevelt elk, there are black-tailed deer, shorebirds, waders, waterfowl, birds of prey, and songbirds. Moderate telephoto lenses should be sufficient to photograph groups of elk; you'll need longer lenses to photograph individuals. Because the viewing areas lie on the south side of the road, you'll always be photographing into the sun, so be aware of possible lens flare.

Elk mothers and young are in the meadows in mid-June, and bulls start bugling in September. The elk are most active early morning and late afternoon.

Directions: At the town of Reedsport, turn east on State Route 38 for about 3 miles to the Dean Creek Elk Viewing Area

Coos Bay Area

Coos Bay, with its huge log mills and deep-water port, used to be one of the main economic centers of the entire Oregon Coast. Now its mills are mostly closed, the log yards mostly empty. The area is trying to revitalize, but the effort is just beginning. If you like photographing the residue of prosperity, you will find plenty to shoot in Coos Bay.

As of this writing a few mills and log-loading operations still cause a pretty steady stream of large ship traffic in the inner part of **Coos Bay (96).** If you like photographing ships and their hubbub, hang around the old docks to be happily occupied. The Coast Highway traces the west side of the inner harbor, providing good access to whatever is happening.

Coos Bay Bridge (97)

This magnificent bridge, officially called the Conde B. McCullough Memorial Bridge, is on the north side of Coos Bay/North Bend on the Coast Highway. Dedicated to its designer, it makes a wonderful photographic subject. For a great shot with the bridge lit up with late light, turn west onto the Trans Pacific Parkway north of the bridge toward Horsefall Beach. Stop anywhere where you can get a good view. Try both wide-angle and telephoto lenses. A telephoto can isolate portions of the bridge for graphic compositions.

If you feel up to a walk, park at either end of the bridge and hike the half mile to its middle for pictures of Coos Bay and any oceangoing vessels passing by.

The *New Carissa* Shipwreck (98)

If you like shipwrecks, a fairly recent one is near the North Spit of the Coos Bay harbor. The *New Carissa* ran aground in 1999, broke in two, and then the bow section was towed out to sea. The stern, though, is still stuck in the sand, rusting away and providing interesting compositions for photographers.

Directions: Follow the Trans-Pacific Highway 4 miles from the north end of the big Coos Bay Bridge to the North Spit Boat Launch. The wreck is a 2-mile walk south down the beach from the boat launch.

Charleston Harbor (99)

The Charleston Harbor is a great traditional harbor full of working boats and lots of fishing gear and other stuff. I think this is the most photogenic harbor on the coast.

Foggy mornings are especially nice. Photographers love fog, fishermen hate it. One old guy told me, "It's like fishin' with a bucket over yer head." Photographers love fog because it greatly reduces contrast, wipes out distracting backgrounds, and creates nice even lighting. Plus bright colors tend to stand out more in fog.

Look for patterns in the masts of fishing boats with wide-angle to normal lenses. Photograph details with telephoto lenses. From the parking area next to the harbor, plenty of shots can be had just by picking an area and starting wide, then zooming in. Next, walk on the docks themselves, and look for details on the boats such as ropes and nets. The harbor is open to the public from 5 AM to 10 PM.

When driving out of the harbor, look for piled nets in some parking areas or next to buildings. These nets, along with the floats and buoys that are almost always attached, make for great pattern shots. Fill the frame with your pattern, and use the colorful floats as accent points in your patterns.

Directions: From Coos Bay or North Bend, depending on where you're com-

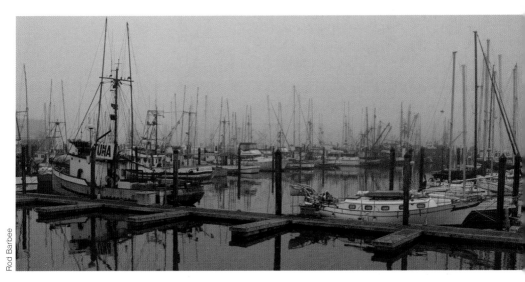

Rod Barbee

Charleston Harbor on a foggy morning

ing from, follow the Cape Arago Highway about 8 miles to Charleston. On the west side of the South Slough bridge, turn north into Charleston Harbor. Drive about 0.25 mile to Kingfisher Drive or about 0.4 mile to Guano Rock Avenue. Either street will bring you to the boat basin.

South Slough National Estuarine Reserve (100)

Located 4 miles upstream from the harbor, the reserve is a great place to explore and shoot if you are in a canoe. You'll have the place to yourself and will see much more, especially animals, if you go by water. Go upstream on the coming tide and downstream on the going tide.

Walkers also have a number of trails to explore. I like going down to the spit bordering the South Slough on the Timber Trail and returning on the Marshside and Hidden Creek Trails. There's an observation platform on the Marshside Trail and a boardwalk through a pretty little wetland on the Hidden Creek Trail. The entire loop is about 2 miles long.

A very nice interpretive center is a great place to learn about the ecology of estuaries. This is a perfect place for families.

Directions: The interpretive center is a few miles south of the Charleston Harbor on Seven Devils Road.

The Cape Arago Area

The town of Coos Bay sits a bit inland in a crook of the bay protected from the ocean by the southern tip (here curiously called North Beach) of the extensive Oregon Dunes complex. Guarding the southern entrance of Coos Bay is the Cape Arago Headland, accessed through Charleston by Route 240, the Cape Arago Highway. This is a must-do route for all photographers because it links three beautiful coastal state parks: Sunset Bay, Shore Acres, and Cape Arago.

Sunset Bay State Park (101)

As the name implies, this is a good place for sunsets. The sun goes down in the mouth of the small but scenic bay, farther north in summer and farther south in winter. If you want to do grand scenics, try the north side of the bay, which has some good foreground possibilities in the sculpted sandstone rocks. When the tide is low enough, you can walk out to where you can get good views of the crashing waves.

If you would like a bit of exercise, a trail leads south from Sunset Bay to Shore Acres and on to Cape Arago State Park. The trail hugs the cliffs most of the way, making for spectacular views around every turn. Some people think this trail is the best place to photograph crashing waves on the Oregon Coast. I can't disagree.

This trail is also accessible at points along the Cape Arago Highway and at Shore Acres State Park and the Simpson Reef viewpoint. The trail north from Cape Arago to Sunset Bay leads through a landscape that seems more appropriate to southern Utah than to the Pacific Northwest. The sandstone bedrock has been shaped and formed by constant bombardment from wind and water, leaving behind bizarre formations. If you want different looking Oregon Coast images, come here and you won't be disappointed.

Directions: Sunset Bay State Park is about 2.7 miles beyond Charleston on the

Cape Arago Highway. The entrance is well signed.

Cape Arago Light Viewpoint (102)

About 0.5 mile past the campground entrance at Sunset Bay is a large gravel pullout with a view of the Cape Arago lighthouse. There's a stairway down to a trail—the same trail that leads from Sunset Bay to Shore Acres—which takes you to the best viewpoint. You'll still be in sight of your car, so you won't have to tote all your gear with you if you don't want to.

This is another good late-afternoon to sunset location. Wide-angle to telephoto lenses can be used here to great effect. With wide-angle lenses you'll be able to include the cliffs and waves directly below you. With waves crashing against the cliffs, try timing your shots to get the best wave action. Telephoto lenses will enable you to focus just on the lighthouse.

Other compositional choices will depend on what's going on in the sky. If there are lots of clouds splashed with color, you'll probably want to include a lot of sky. If it's one of those sunsets without clouds, think about cutting out the sky and featuring the light on the cliffs.

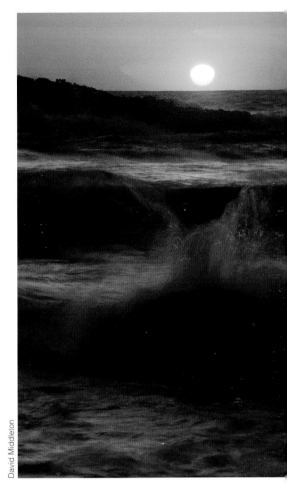

David Middleton

Sunset on the coast

Shore Acres State Park (103) and Simpson Beach (104)

Shore Acres is a place you'll want to budget some extra time for because there's so much to see and photograph here. Once the home of lumberman/shipbuilder Louis J. Simpson, the estate features unbelievable gardens with plants from around the world. (In 1942 the state of Oregon, in an unusual bit of foresight, purchased the property for use as a public park. Thank you, state of Oregon.)

The formal gardens are at their peak during spring and summer months, with rhododendrons and azaleas blooming in May and June and the roses in June and July. You'll probably want to immediately start photographing in the gardens, but do yourself a favor and just walk around, explore, and enjoy them first; you'll likely find better photographs this way. Be sure to check out the pond area for reflections.

I'd suggest bringing just about all the lenses you have for these gardens. Everything from ultra-wide-angle lenses to telephotos can be used. You'll want a lens

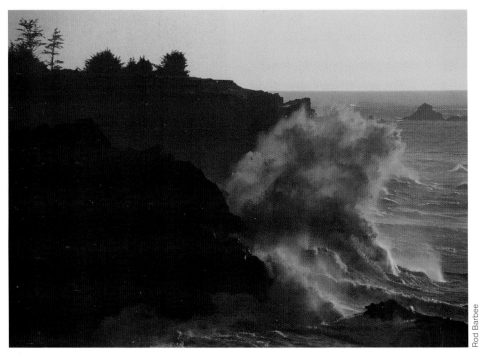

Crashing waves at sunset: Shore Acres State Park

that allows you to photograph up close, as well. And bring lots of film or flash cards.

This place lends itself to graphic compositions. Look for lines in the walkways and curves in the shrubs and garden borders. Think of tying together foreground flowers or fountains with background trees or buildings. If you're here between Thanksgiving and New Year's, you'll be treated with the annual holiday light display.

Besides the formal gardens, Shore Acres is also known for **dramatic sea cliffs** and **huge crashing waves.** Great crashing wave photos can be had from right in front of the observation shelter located west of the main parking lot. Time your visit for an incoming tide, especially an extrahigh tide, and you may just be rewarded with huge waves to shoot. This is also a good

spot to visit during a winter storm; just don't let yourself get blown over.

From the parking lot a trail leads south, skirting the edge of the gardens. The trail leads south toward Cape Arago, but first it takes you to a small cove and **Simpson Beach,** a pleasant little beach surrounded by sandstone cliffs. Sea lions will sometimes haul out on this beach. If you see one, don't approach too closely; use a long lens. Also try getting your tripod as low as you can so you'll be photographing at the animal's eye level.

On the north side of the beach, look for rocks to use in landscape foregrounds; waves crashing at the mouth of the cove will serve as a background. This is also a good place to explore tide pools at low tide.

Continue on the trail toward the Cape

Arago State Park. You'll come to a couple of places where the cliffs are very steep and very high. Be very careful at the edges of these cliffs. You'll find more opportunities to photograph rugged cliffs and crashing waves. One particular place that's about 0.5 mile from Shore Acres juts out a little ways into the ocean. Here you'll be able to photograph south toward Simpson Reef and north to rugged cliffs. This would make a good sunset spot. Since the park closes at dusk, you may want to park at a pullout 0.9 mile from the park entrance and walk about 0.25 mile back toward Shore Acres.

Directions: The entrance to Shore Acres is another 0.4 miles beyond the Cape Arago viewpoint. There's a $3 entrance fee. If you have an annual pass or you're staying at Sunset Bay State Park, you won't need to pay. The park is 13 miles southwest of Coos Bay.

Simpson Reef Viewpoint (105)

This viewpoint atop a cliff gives an outstanding view down on Simpson Reef and Shell Island, a year-round haul-out for hundreds of sea lions and seals. This is probably the best place on the Oregon coast to view these sea mammals. You'll be able to see California and Stellar sea lions, northern elephant seals, and harbor seals. Binoculars or a spotting scope are a must.

Photographically speaking, it's not the greatest place to capture images of these creatures; they're just too far away. Even using a 500mm or 600mm lens with a teleconverter, you'll only be able to photograph large groups. But stop by here, anyway, and take a look (and listen). This is just something you owe yourself to experience.

Directions: The viewpoint is 1.1 miles from the Shore Acres State Park entrance.

Cape Arago State Park (106)

At the end of the Cape Arago Highway, Cape Arago State Park offers still more spectacular ocean scenery: more trails to walk, more coves to explore, more crashing waves to capture, and more astonishing coastal landscapes to photograph.

There are two main trails in the park, one leading to a beach on the north side of the cape with tide pools and crashing waves, the other to—yes—a beach on the south side with tide pools and still more crashing waves. (Have enough pictures of crashing waves yet?)

A picnic area on the cliffs overlooks the water. Come here in the middle of the day to just relax and hang out. Pay some attention to see if there are migrating whales offshore.

Directions: Cape Arago State Park is about 5 miles from Charleston off the Cape Arago Highway.

South of Coos Bay

Bandon Area

Bandon Beach has perhaps the most photogenic sea stacks and pillars on the Oregon coast. Plus Old Town Bandon is one of the most appealing and photogenic coastal towns. Other highlights include the Coquille River Light, Coquille Point, South Jetty Park in Old Town, and Bandon State Park. Keep this place a secret, or else it will turn into another Cannon Beach—and we wouldn't want that!

Also in the area are numerous commercial cranberry bogs. The berries are brightest red in the fall—the time of the

cranberry harvest. Be sure to ask permission if you want to take pictures of this very photogenic plant and process.

Directions: Bandon is about 20 miles south of Coos Bay or about 37 miles north of Port Orford on Highway 101.

Old Town Bandon (107)

Old Town Bandon is not a very big place—maybe 6 blocks by 3 blocks—and it's right on Route 1, but it's a refreshing stop and well worth carrying your camera for. The last time I was in Bandon, a red neon sign in the window of a small shop caught my eye. It advertised Seafood Espresso. I'm pretty sure that meant they had both seafood and espresso, but this being the Oregon coast, I can't say that I am positive.

South Jetty Park (108)

This park sits on the south side of the mouth of the Coquille River, with the cliffs of the Bandon shore to the south and the dunes and beach of Bullards Beach to the north across the river. Also across the river is the diminutive **Coquille River Light** (see the next site).

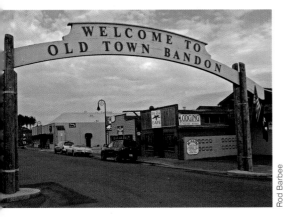

Entrance to Old Town Bandon

You can photograph the lighthouse and the constant boat traffic on the Coquille River from South Jetty Park with a short telephoto lens. To photograph just the lighthouse, use a longer telephoto, or drive around to the lighthouse itself. The South Jetty is especially dramatic in morning fog.

Some of the best shots of the lighthouse can be had next to the Bandon Boatworks Restaurant. If photographing at sunset, the lighthouse will be more or less side lit, depending on the time of year. If colorful clouds are present, think about using a wide-angle lens and placing the lighthouse at the bottom of the frame to make the most of the sky. Don't forget to look for reflections in the river.

Directions: Drive south on First Street past the Old Town waterfront and the post office. Look for the BEACH ACCESS sign, and turn right to the south jetty.

Bullards Beach State Park (109) and Coquille River Light (110)

Bullards Beach is the southern end of a long stretch of beach that extends north almost all the way to Cape Arago. At Bandon the Coquille River curves around the beach, forming a long spit ending at the mouth of the river and the North Jetty. The **Coquille River Light** sits at the base of the North Jetty. A good road leads from the Coast Highway through the dunes to the beach and down to the lighthouse.

A better way to explore the park is to walk the beach and return via the back beach along the edge of the Coquille River. The entire loop trail is about 3.5 miles and makes for a nice morning or late-afternoon walk.

The lighthouse sits on a small patch of

rocks and is often surrounded by great piles of driftwood. The scene can be a bit cluttered, with the parking area, cars, and the lights of Bandon interfering with a nice composition. Shooting from a low perspective allows you to hide the clutter around the lighthouse behind dunes, beach grass, or beach logs.

This location is also a good place to see wildlife. Cormorants may be perched on the pilings along the back beach, drying their wings, and there are always sandpipers on the mudflats in the river.

Directions: Drive north of Bandon on Highway 101 and cross the bridge. Turn into Bullards Beach State Park, and follow the road to its end at the Coquille River Light.

Bandon Beach Area

Bandon Beach is well-known because of the maze of sea stacks that litter both the beach and the near shore waters. The beach is wide and clean and goes on forever, and you'll likely see only a few other people on it. This is my favorite beach on the West Coast, and in one visit it will be yours, as well.

There are several access points to the beach, all from Beach Loop Road. Turn west on Eleventh Street Southwest off the Coast Highway on the south side of Bandon. Go 0.9 mile to a four-way stop. Turning left will put you on the north end of Beach Loop Drive.

Coquille Point (111)

Coquille Point marks the tip of the Bandon headland and is part of the Oregon Islands National Wildlife Refuge. From the point there is easy beach access and a fantastic overall view of Bandon Beach to

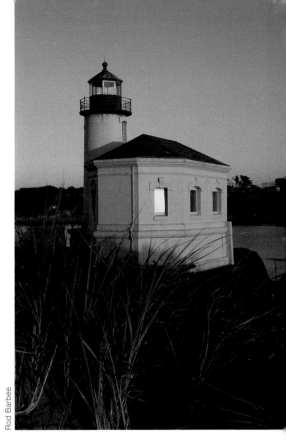

Rod Barbee

Coquille River Light at sunset

the south. You can use wide-angle to telephoto lenses here, so bring them all.

A stairway leads from the parking lot down to the beach where at low tide you can walk among the sea stacks. At high tide, photograph the stacks in the breaking surf.

Heading off north of the parking lot is a paved trail that leads to several viewpoints to photograph the sea stacks and surf. Pack a long telephoto, and you may be able to get some puffins or other birds in your viewfinder.

Directions: From the four-way stop at the beginning of the Beach Loop Drive, continue straight past the motels to Coquille Point.

Sunset Motel (112)

This is just about the best beach access in Bandon, but you must be registered at the Sunset Motel to park in its lot or along the road. Half the motel is built on the sea cliff face, so the views from the rooms are more than spectacular. Stay here and you can literally photograph the sunset and the sea stacks in your pajamas.

If you don't stay at the Sunset Motel, the Face Rock Wayside is only about 0.10 mile south, so you could park there and walk back. A stairway descends through the motel and leads to the beach full of rock spires and sea stacks.

Most people think of photographing sunsets on the West Coast, but sunrise photography on this beach can be very rewarding. On a clear morning the sky will become pink and blue, and you can use the tidal pools to reflect this color, along with the sea stacks and spires. Some clouds in the sky catching the first light is all the better.

Directions: The Sunset Motel is about 0.5 mile south of the four-way stop on the Beach Loop Road or about 2 miles from the center of Bandon.

Face Rock Wayside (113)

Face Rock, an offshore rocky island that has an outline that resembles a face, is one of the best-known and most photographed landmarks on the Oregon Coast. You can photograph from the parking area, or, for more variety, take the stairway on the south side of the parking area down to the beach.

From the beach you'll find one of the most concentrated groupings of sea stacks on the coast and far fewer people than at the wayside above. Walk south for

more views of Face Rock and other sea stacks, or walk north, rounding the headland, to more beach and sea stacks. Or just stay put and spend your time taking a great photo.

Directions: One-half mile south of Coquille Point on Beach Loop Drive.

Bandon State Park (114)

The entire beach here is part of Bandon State Park. Several waysides along Beach Loop Drive provide access to beach areas. They're all worth a look-see, though most of the sea stacks and offshore rocks are on the north end of the park near the Face Rock Wayside. Still, the beach is wide and long and very inviting.

About 1.6 miles south of Face Rock Wayside you can access the beach and a small stream emptying into the ocean. Play around with the curving streambed and wave and beach reflections in the stream water.

About another mile down the road is another wayside. The attraction here is a pond on the east side of the road. Take pictures of reflections of sunrise colors, create ethereal fog images, or perhaps photograph some of our avian friends.

Recommendations: This is another "where do I start?" coastal area. You can spend a very happy, productive week just working the Cape Arago Highway and photographing harbors, gardens, and coastal scenery. But if you went to the fabulous Bandon Beach area first, I don't know how you would ever pull yourself away long enough to explore the Cape Arago area. Such is the agony of a photographer on the Oregon Coast.

I would certainly spend a few days in each area to have time to get the best pho-

tography. Like everywhere else on the coast, if it's foggy, go to a harbor—in this case, Charleston Harbor—and then head for the coast. On cloudy days look for smaller scenes and details, such as at the gardens at Shore Acres State Park. Sunsets are great at both Cape Arago and the beach at the Face Rock Wayside.

Pro Tips: The trick to getting great sunset shots is composing so that the elements are as separated as possible. This is especially true with sea stacks because they will appear as black blobs in your picture, and if you shoot several sea stacks, your picture will be mostly black and blobby and not very pretty.

Walk the beach to find an angle where each of the sea stacks in your composition is outlined by water and/or sky. Then place the setting sun so that it falls between the stacks. Finally, find a little pool in the sand to add some reflections. This isn't the easiest thing to do, but the final picture is worth the effort.

And don't leave the beach when the sun disappears below the horizon. Twilight is a great time to photograph the coast because you'll have to use such a slow shutter speed that the waves will either be rendered as soft, cottony blurs or turned into spooky-looking mist.

Be on the lookout for the unexpected. Even if it's cloudy, you never know if there'll be an opening for the sun to get through. These can be the most dramatic moments you'll ever capture on film (or memory), but you have to be ready. Being familiar with your camera and the technical side of photography is invaluable.

Cautions: Not all waves are created equal, so don't get surprised by an especially big one. And be sure your camera

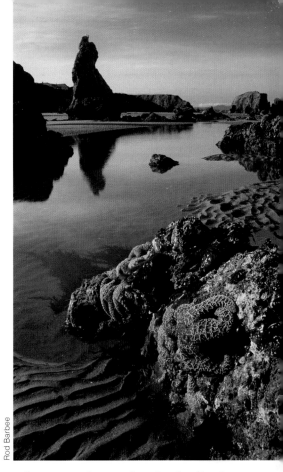

Rod Barbee

Sea stars and sea stack on Bandon Beach

bag is *well* up the beach, so *it* doesn't get soaked, either. If you wade into the water to get a better shot, your tripod will sink in the sand, and your feet will very quickly turn to ice—assuming you don't get swept out to sea by a sudden surge. It's always better to live to shoot another day.

Remember to clean your gear at the conclusion of every coastal photo shoot. Sand gets everywhere, and salt from mist and spray can cover unprotected equipment. I wipe my gear down with a damp cloth and rinse my tripod with fresh water after every trip to the beach. And blow any grit off your lenses before you wipe them or you might scratch your glass.

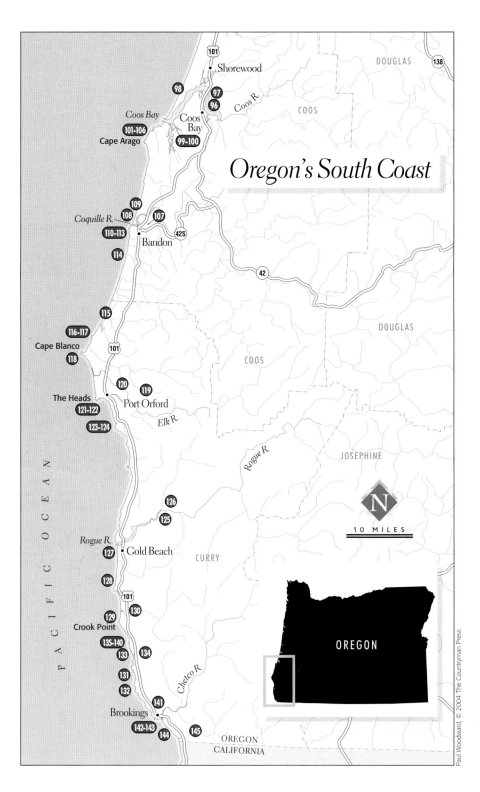

Oregon's South Coast

Shorewood

Coos Bay
Coos R.

101

138

DOUGLAS

COOS

Cape Arago

Coos Bay
99-100

101-106

98

97
96

Coquille R.

109
108
107

42S

110-113

Bandon

42

114

DOUGLAS

115

116-117

Cape Blanco

118

101

COOS

120

119

The Heads

Port Orford

121-122

Elk R.

123-124

Rogue R.

JOSEPHINE

126

N

10 MILES

125

Rogue R.

127

Gold Beach

CURRY

128

101

129
130

Crook Point

135-140

133
134

131

Chetco R.

132

141

Brookings

142-143
144
145

OREGON
CALIFORNIA

OREGON

Paul Woodward, © 2004 The Countryman Press

The South Coast

VII. The South Coast Area

SPRING ★ ★ ★ ★ SUMMER ★ ★ ★ ★ FALL ★ ★ ★ WINTER ★ ★

General Description: The south coast of Oregon is entirely different from the rest of the coast. Protected to the east by the scrambled Siskiyou Mountains, it is remote and consequently difficult to get to. Because it's so hard to get to, most of the spectacular coast is empty, and the pictures you take are therefore refreshingly new. This is a bit of heaven you will have to yourself and never want to leave.

Directions: You really can't get to the southern coast of Oregon conveniently, thank goodness. Coming from northern Oregon, drive in from Eugene, and then drop south through Florence. Coming from southern Oregon, you'll have to cut south into California to Crescent City, and then drive north on Route 101.

Specifically: The Coast Highway follows the southern Oregon coast but never very closely. This means that the headlands and beaches require some getting to, but they also lack most commercial development. Being the wildest part of the coast, the southern coast offers the most potential to nature photographers.

New River (115)

During a flood in 1890 a new channel to Floras Lake was formed, creating an isolated beach and a new river. Hence the name. The area has been designated as "A Globally Important Bird Area" and is full of wildlife, including wading birds, waterfowl, turtles, and deer and other

Where: The southernmost part of the coast, south of Bandon

Noted for: Rhododendrons, old-growth forests, harbors, and spectacular seascapes

Best Time: Late May

Exertion: Minimal to moderate hiking

Peak Times: Spring: late May; summer: late June; fall: October; winter: December

Facilities: At developed sites

Parking: In lots

Sleeps and Eats: In Brookings, Gold Beach, and Port Orford

Sites Included: New River, Floras Lake State Park, Blacklock Point, Cape Blanco State Park, Grassy Knob, Port Orford, Port of Port Orford, Port Orford Head State Park, Redfish Rocks, Humbug Mountain State Park, Shrader Old-Growth Trail, Myrtle Tree Trail, The *Mary D. Hume*, Cape Sebastian State Park, Meyers Beach/ Pistol River, Cape View Loop, Boardman State Park, Cape Ferrelo, Whalehead Beach, Oregon Coast Trail, Indian Sands, North Island Viewpoint, Natural Bridges Cove, Thunder Rock Cove, Arch Rock Point, Deer Point, Harris Beach State Park, Azalea Park, Pelican Bay Lighthouse, Easter Lilies, Oregon Redwood Nature Trail

mammals. Vehicles are not welcomed here in summer to protect endangered snowy plovers. The beach is only accessible by boat.

Consult the map in the parking area near the learning center, and then hike down River Road. You'll soon see a small parking area on your left and a trailhead. This trail leads to the Old Bog and Muddy Lake Trails.

Muddy Lake Trail leads to Muddy Lake and a viewing platform/blind. Expect to see gulls, ducks, and lots of waterfowl, including swans during migration. Get here early morning or late afternoon May through October for best wildlife viewing.

Muddy Lake Trail continues its loop—along this section a side trail leads off to New River, where shorebirds, waders, and others may be spotted—and rejoins River Road.

Directions: About 13.3 miles north of Cape Blanco or 8.6 miles south of the last stop light in Bandon, turn west off Highway 101 onto Croft Lake Lane; a sign directs you to New River. At 1.5 miles bear right, and continue to the parking area and learning center, about 0.5 mile. From there, gated River Road goes to a boat ramp and parking. From March 15 to September 15 the road is closed to motorized vehicles to protect western snow plovers.

Floras Lake State Park (116) and Blacklock Point (117)

Floras Lake State Park is seldom visited and rarely photographed. This is probably as much because it's well off the Coast Highway as it is due to the exertion necessary to see most of the park. But the tall,

impressive sea cliffs of **Blacklock Point** and views of a 150-foot waterfall falling into the ocean make this hike well worth the effort, even if you have to hike back in the dark after sunset. Be sure to pack a flashlight or headlamp.

It's an easy, level 2-mile hike to Blacklock point (4 miles round-trip) and another 0.8 mile to the waterfall area (5.7 miles round-trip). The beginning of the trail parallels the airport runway for a short distance. Bear left at an unmarked junction 0.8 mile from the trailhead, and then follow the trail markers the rest of the way. The trail ends in a meadow at the tip of the point.

Views from this isolated point are spectacular. To the south, the shoreline arcs away to Cape Blanco in a long, gentle curve. To the north, sheer cliffs march into the distance. All lenses are useful here, from a wide-angle 20mm to a 400mm telephoto, but you could also be perfectly happy using a single 28–200mm zoom.

For even better views of the impressive cliffs to the north and the waterfall, hike back to the last trail junction, and turn left. After about 0.75 mile you'll come to the first of several boardwalks over wet areas and a stream. After the third boardwalk (this gets a little tricky), look for a faint trail to the left into an open area. This trail leads through a thin line of coastal pines. Push through to an open, sandy space at the top of the cliff. Make your way to the left, and you'll see the waterfall. This scene is best to photograph in spring and early summer.

This isn't the best view of the waterfall, but it leads to the best view of the cliffs. Work your way toward the falls, and you'll see where you can cross a small stream after descending a sand slope. Hop the

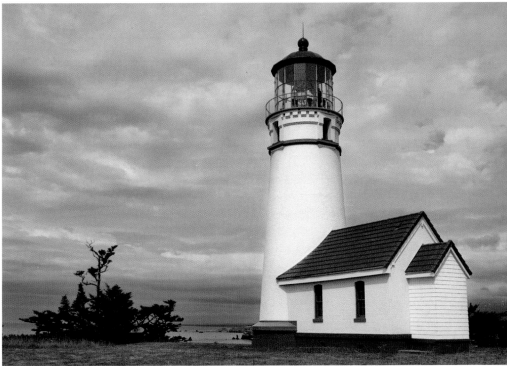

Cape Blanco Light, Cape Blanco State Park

stream, and work your way out to the cliff area on the south side of the falls. The walls light up at sunset, making getting here worth the work. There are no guardrails, and it's a long way to the beach below, so be very, very careful near the cliff edges. Also, it's often windy here; don't let a strong gust knock over you or your tripod.

For a better angle to photograph that waterfall, return to the trail, and continue toward Floras Lake. Check the open areas along the way for clearer views of the falls.

I know it's a bit of a hike, especially if you're coming out for a sunset photo, but you'll have a pleasant hike, see a unique landscape, and probably have it mostly to yourself. Oh, and you'll get some great shots.

Directions: Drive north of Port Orford for about 7 miles, and turn west at the sign for the Cape Blanco airport (County Road 160). Follow this road 2.8 miles to its end at the gated entrance to the airport. The trail is to your left.

Cape Blanco State Park (118)

Cape Blanco is the westernmost point in the state of Oregon. The main feature here for photographers is the Cape Blanco Light, the oldest standing lighthouse in Oregon and one of the prettiest. Plus the lighthouse is situated in such a way, with flat land to the east, that it can be photographed at sunrise as well as sunset.

The west side of the lighthouse is best for catching the last light on the lighthouse. If you have colorful skies to the

west, consider photographing from the east side, perhaps silhouetting the lighthouse against the brilliant sky. If you set up on the south side, you can include a view of Blacklock Point in your background. At sunrise just the opposite applies, as far as which side to photograph from—and if you're lucky, you'll have morning fog.

From the right side of the parking lot next to the gate, make your way to the beach. Here you can find tide pools, driftwood, and more seascapes to photograph. Blacklock Point will be in the distance.

From the left side of the same parking lot, you look down to a beach and a single rock spire with the dark-blue ocean as its background. At sunset one side of this spire will be bathed in a warm glow, and the incoming waves will be catching the same light. Use a short telephoto to isolate this spire.

For beach-level shots of the lighthouse, descend to the beach using the trail near the gate at the lighthouse road, and hike north until you get the view you want. For views from the south, drive to the campground, and follow the signs to the beach. You can't drive to the beach since the road severely deteriorates toward the end. Find a place to park, walk down to the beach, and turn north toward the lighthouse. Be aware of tide times.

Just in case you run out of things to do in the park, Cape Blanco is also a good place for whale watching.

Directions: Drive 9 miles north of Port Orford, and turn left at the sign for Cape Blanco State Park. From the gated entrance a narrow road leads to the lighthouse. The gate is locked at 3:30 PM, so if you want to photograph the lighthouse at sunset, park at the gate and walk the short distance to the lighthouse.

Grassy Knob (119)

This thoroughly unimpressive-looking mountain was once the focus of an intense wilderness-versus-logging debate. Wilderness won, but not before a logging road was pushed into the wild forests and meadows of Grassy Knob.

This is not a hike for people who like impressive summits with incredible vistas. This is an easy walk for wildflower and forest photographers who like lots of beautiful things to photograph close at hand. The flowers are best in May and June, but some are present through summer. The forest is best anytime there is rain, snow, or fog.

The trail starts at the barricade and follows the old, overgrown logging road up a gradual ridge. Less than 0.5 mile from the start a side trail climbs to the summit of Grassy Knob, with views west and south.

Directions: Turn east off the Coast Highway onto Grassy Knob Road 0.25 mile south of the Cape Blanco entrance road. Follow this road for almost 8 miles (the first half is paved, the second is gravel) to its terminus at the trailhead. It's 0.5 mile to the summit and about 1 mile to the end of the logging road.

Port Orford (120)

Port Orford, 38 miles south of Bandon and about 27 miles north of Gold Beach, has one of the most interesting ports on the West Coast. There is actually no harbor. Instead of boats mooring in protected water or at a dock, a crane hoists

them in and out of the water like a child picking up toys and putting them away for the night.

The best view is from the Port View on Oregon Street. At the top of the hill there's a small shelter. This gives a good overview of the port and the surrounding coast.

Port of Port Orford (121)

Turn west on Harbor Drive, following signs to the port. The road approaches from above the port, where there's a large gravel parking area. This is a good spot to get wide, scenic shots of the port. If you're lucky, a boat hoisting will be in progress.

Next, drive down to the port and wander around the dry-docked boats. Visitors are welcome, but this is a working port, so keep your eyes out for moving vehicles and large boats dropping out of the sky. This port gets pretty good light in the morning. Also that's when most of the fishermen are heading out to sea, so a lot will be going on to photograph.

Port Orford Head State Park (122)

This small state park sits at the tip of the small headland that defines the Port Orford area. Follow the easy 0.5-mile trail to an ocean overlook. To the south are sea stacks and Humbug Mountain; north, Cape Blanco; below, the rugged headland and crashing waves. After you've made your dramatic-rocks-and-crashing-waves shot, look for foreground possibilities, like flowers in spring and summer or perhaps the trail itself. Well worth the short hike. A lifeboat interpretive display is here, as well.

Directions: Turn west on Ninth Street and left on Coast Guard Road, following the signs.

Redfish Rocks at sunset

Redfish Rocks (123)

This grouping of five sea stacks—one large, the others smaller, like a mother flanked by her children—makes for a serene and pleasing scene. A 28–70mm zoom will enable you to frame all the rocks; a longer lens will allow you to zoom in on just a couple of them. This is an excellent sunset location made better when clouds add some overall color.

The time of year and where the sun is going down will dictate where you stand. Good views can be had from the south side of the parking area—there's an opening in the guardrail. Or walk across the street, and climb up the embankment a little ways for a better view.

Directions: Some 1.5 miles north of the Humbug Mountain Campground entrance; park in a large turnout on the west side of the road.

Humbug Mountain State Park (124)

Humbug Mountain is a lump of steep forest that the Coast Highway skirts around on the inland side just south of Port Orford. You'll know you're there when you can't see the ocean for the trees.

Despite its name, this is a delightful park, especially for those who love forests and wildflowers. The only access is on the 5.5-mile loop Humbug Mountain Trail that starts at the well-signed parking area 6 miles south of Port Orford.

You don't have to go far to find something to photograph on this trail. Maidenhair ferns, huge maple and myrtle trees, and a pretty stream are all close to the parking area. I think this is the best part of the trail, so linger here. The trail steeply climbs Humbug Mountain to two viewpoints that are 1.5 miles and 2.5 miles away. But I don't think the views are worth hauling yourself and photo gear on up. For photographing a sunset, you'd have a long walk back in the dark, and there are better and easier places.

Directions: Take Highway 101 some 21 miles north of Gold Beach or 6 miles south of Port Orford to the HUMBUG MOUNTAIN TRAIL PARKING sign, just north of the entrance to the campground.

Shrader Old-Growth Trail (125)

This is an easy 1-mile loop trail thorough a magnificent old-growth forest with huge Douglas firs and Port Orford cedars as well as some very nice myrtle and tanoak trees. Plus there are some huge rhododendrons to photograph. The trail crosses several small streams to add some variety to your pictures.

A great time to visit is late May and June, when the rhododendrons are blooming. Pick an overcast or rainy day, and use a polarizing filter for best results. You'll need a tripod because your shutter speeds will be very long. Use wide-angle lenses to portray the expanse of the forest; use normal to short telephoto lenses to

pick out details that catch your eye. You should find plenty to photograph here.

Directions: From Highway 101 in Gold Beach, turn east at the north end of the bridge on Jerry's Flat Road. Drive 11.2 miles, and turn right at the sign for the Frances Shrader Memorial Trail. Road 3300–090 climbs 2.1 miles to a parking area.

Myrtle Tree Trail (126)

Since you're already in the area, after you've photographed the Shrader Old-Growth area, drive back to Jerry's Flat Road, and turn right. In 0.1 mile turn left on Road 3310, cross the bridge, and turn right on Road 3533. Follow this for 1 mile. The 0.3-mile trail climbs to the largest known myrtle tree in Oregon. It's not a fantastic photo opportunity, but it is a fantastic tree.

The *Mary D. Hume* (127)

The *Mary D. Hume* is an attractive half-sunken boat in the port of Gold Beach. I know, "attractive" and "half-sunken" don't normally go together, but in this case they work. Built in 1880, the ship was in service for 97 years performing various jobs, including tugboat and cannery tender. The plan was for her to become a tourist attraction in the port, but she suffered irreparable damage and sank at this spot in the river. She does indeed, though, serve as a tourist attraction and a photogenic, fun subject.

Directions: From Highway 101, just south of the bridge in Gold Harbor, turn onto Harbor Way to the port of Gold Beach. The *Mary D. Hume* sits in the water at the east end of the port near an interpretive sign.

Cape Sebastian State Park (128)

More than 200 feet above the ocean, the Cape Sebastian viewpoint is one of the most impressive on the coast. About 5 miles south of the Pistol River, turn west into Cape Sebastian State Park. For the best view, keep left at an intersection, and drive to the parking lot.

The view right from the parking lot is spectacular. Some nearby trees will creep into the lower part of you pictures, so find the highest point you can. If you're driving an RV or a pickup truck, consider using your vehicle as a shooting platform. A trail leads from the parking lot across a meadow to another good viewpoint. Continuing, the trail switchbacks down to more viewpoints.

The wind here can be ferocious, as evidenced by the bent spruce trees. If it's blowing, use the fastest shutter speed you can to stop any wind-induced vibration, especially if you're using a telephoto lens.

Meyers Beach (129)

Known for its pretty beach and close sea stacks, Meyers Beach is 1.7 miles south of Pistol River. Several turnouts along the Coast Highway get to this beach, but the best access to the sea stacks is from the large paved turnout.

At low tide it's possible to wander among the sea stacks; one even has an arch. If you pick your spot properly, you can get sunset light coming through the arch. If you're on the beach near the sea stacks, use a wide-angle lens to capture the entire scene.

Cape View Loop (130)

This little-known road runs parallel to and right above Highway 101 for about a mile and has some of the best ocean views in the area. Turn east on the Meyers Creek Road, which intersects Highway 101 across one of the large gravel pullouts near mile marker 337. At a fork keep right

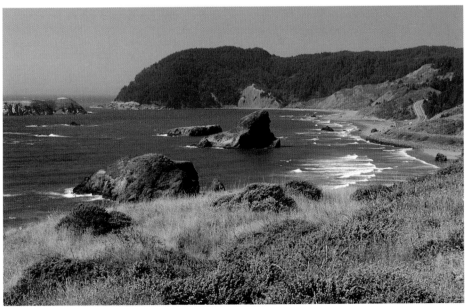

Rod Barbee

Cape Sebastian in background from Pistol River State Park

Rod Barbee

Rock formation on Whalehead Beach,
Boardman State Park

Boardman State Park (131)

Named after Oregon's first parks superintendent, Boardman State Park is a narrow 12-mile strip of the most scenic coastline to be found in the state. You can photograph from many of the pullouts on the Coast Highway, but the best views will be found by taking brief hikes to the water's edge. The Oregon Coast Trail parallels the highway, so the entire park is easily accessible by short drives or short walks.

The sites below are all sections of Boardman State Park, arranged south to north because most people stay in Brookings to explore Boardman, which is on the south end of the park.

Cape Ferrelo (132)

Cape Ferrelo is accessed by an easy 0.5-mile trail with good views of Lone Ranch Beach (the southernmost point of Boardman State Park) and piles of sea stacks to the south. The view north is also worth photographing. This is a good spot for sunset and very easy to get to.

Directions: Cape Ferrelo is about 2.5 miles north of Brookings.

Whalehead Beach (133)

Triangular Whalehead Rock got its name from the way water "spouts" over it when the tide is just right. Ironically, from the viewpoint above, the two rocks to the left of it sort of blend together to create the shape of a whale, while Whalehead Rock looks nothing like a whale.

For the best photography, park at the picnic area, and follow the short trail to the beach. Walk south to where the trail from the viewpoint meets the beach. Hike up the trail approximately 20 yards for a clear view of the beach.

to Cape View Loop. In about 0.25 mile you'll come to a viewpoint just above the Meyers Creek Beach Wayside and its collection of sea stacks (see above).

Photographs can be had looking both north and south. To the south the view is of sea stacks, the curving beach, and Cook Point in the distance. To the north, more sea stacks, beach, and Cape Sebastian. Take some pictures that include the foreground grasses and shrubs. In spring and early summer look for wildflowers to add a splash of color.

On the beach, be sure to look for a large, stream-fed pool at the base of the trail leading from the picnic area. On a calm day this pool can be used for reflections, especially during evening twilight. Also, try setting up with the "spout" backlit, and wait for the incoming surf to spray water into the air.

Directions: Approximately 5 miles north of Brookings on Highway 101.

Oregon Coast Trail (134)

Access the Oregon Coast Trail near the top of the road leading down to Whalehead Beach. Hike a steep 0.25 mile to good views of Whalehead Beach and the rocks below. When the trail breaks into the open, a spur trail to the left leads to a bluff. Look for open areas to the left off this trail. This is a good spot to photograph sunset, catching the last light accenting the waves and rocks below as well as the forested headlands.

Indian Sands (135)

From the south end of the parking lot, take the short, steep trail down to a sand and cliff area and an intersection with the Oregon Coast Trail. Once you get to the sand and where you can see the ocean, go left (south) for views of a sea arch. Be very careful here as the cliff edges are unstable and can easily give way. There are places, in fact, where you can see where the trail *used* to be.

Explore small coves with crashing waves, the sea arch, sand dunes, and wind-sculpted sandstone. You'll also see the brightly colored sea fig *(Carpobrotus chilensis)* a non-native succulent with pink and purple flowers that bloom from April to September. These plants were introduced to stabilize sand dunes along California's coastal highways and have spread all the way up here. Native lupines are also present if you don't like to photograph aliens.

After checking the area to the south, follow the coast trail north a little ways for more views of the rugged coast. At a low point in the trail you look down at a smooth sand beach. This is probably the best view north.

Directions: Just 0.8 mile north of Whalehead Beach, about 7 miles north of Brookings.

North Island Viewpoint (136)

From this viewpoint there's a great view south to Indian Sands and the Thomas Creek Bridge as well as easy access to the Oregon Coast Trail for still more terrific views. Access the trail from the signed trailhead on the south side of the parking area; the trail intersects 60 feet from the sign. Go left on the trail; it gently descends toward a meadow where a spur trail cuts off to the right.

Follow the trail, and soon you'll see it climbing to your left to the top of a bluff. Follow to the end for a remarkable view to the south. This location is best photographed in late afternoon for the best light on the cliffs and the Thomas Creek Bridge, which, at 345 feet, is the highest bridge in Oregon. This is an easy 10-minute walk and another good place for a sunset.

Directions: About 0.25 mile north of the Thomas Creek Bridge.

Natural Bridges Cove (137)

Take the trail at the left side of the parking lot for about 100 feet to a view of Natural

Bridges. Though not a great viewpoint, it's the best there is. Use a zoom lens in the 28–70mm range to help eliminate the clutter of trees. It's probably best photographed at a normal to high tide so that there's water in the cove and midmorning for best color in the water. By afternoon the shadows are harsh, and the water looks dull. This is really just a postcard shot.

Directions: Natural Bridges Cove is about 1.8 miles north of Thomas Creek Bridge.

Thunder Rock Cove (138)

Either walk the trail from the right side of the Natural Bridges parking lot, or drive a few hundred feet north to the Thunder Rock Cove parking area. You'll end up in the same place, regardless. Hike the trail from the parking lot, and go left at a fork. You'll have plenty of views of the cove and its arch rock, but it's hard to photograph because of all the trees.

A few spots, however, offer a decent view. A 28–70mm is probably all you need to eliminate distracting trees from poking their way into your pictures. Or use the trees, in silhouette form, as framing devices.

Continue to the end of the bluff for good views north and south. This is a nice spot for late afternoon and sunset photography using wide-angle or normal lenses, though you may want your telephoto to pick out pieces of the landscape.

Arch Rock Point (139)

Arch Rock picnic viewpoint is 1 mile north of Thunder Rock Cove. The view south from the parking lot is pretty good, and a paved trail leads to other viewpoints. One of these looks south but is slightly obstructed because a low fence keeps you well back of the best place to photograph this scene. The same can be said for the viewpoints for Arch Rock itself; trees make photographing from these "official" viewpoints very difficult.

For a less obstructed view, walk or drive north about 0.2 mile to another pullout. On the south end of this pullout is a good viewpoint. You'll see the place: an indentation in the bushes where other photographers have come before you. An 80–200mm zoom will work well here; if you want to take in more of the foreground trees, use a 28–70mm.

Deer Point (140)

At the northernmost end of Boardman State Park, this unmarked turnout 0.5 mile north of the Arch Rock picnic area connects with the Oregon Coast Trail. Arch Rock can be seen from this viewpoint. However, from this angle the arch is not visible. The trail leading from the pullout passes a park bench, and side trails lead to the end of the point and the beach on the south side. A crescent-shaped cove lies to the south. You'll need a wide-angle lens to take it all in. If you follow the trail to the beach below, it's possible to walk south and photograph the sea stacks against the sunset sky.

Harris Beach State Park (141)

At the north end of Brookings, this very scenic park has a lot to offer. Plus, if you're camping, it's a good place to base yourself while exploring Boardman State Park and the rest of the area.

Drive into the park, and pass the campground area, parking in the day-use area. The beach is easily accessed from here. A stream empties into the ocean, and often

wide pools can be utilized for sunset reflection. Try silhouetting the gulls that hang out at the edge of the pools.

A trail across from the campsite entrance booth leads a short distance to the top of Harris Butte, giving you a different, more aerial view of the beach below. I'd advise hiking the Harris Butte trail at midday for seascape possibilities, and then staying to photograph the sunset from the beach.

There is also the Marine Gardens. A trail across from the campground entrance leads down to a rocky beach and tide pools.

Another trail originates from the first parking lot you come to as you enter the park, and leads to a sandy beach. Here you have more access to tide pools plus good views of sea stacks.

Brookings

If you're in the area to photograph Boardman State Park, Brookings is an ideal town to base yourself in. Aside from reasonably priced motels, plenty of grocery stores, and places to eat, some good photo opportunities are very close by.

Azalea Park (142)

A former state park turned over to the city in 1992, Azalea Park is maintained by local volunteers and is a must stop for all photographers. Besides azaleas and rhododendrons, there are also lots of other flowers in the gardens. The gardens are laid out with meandering sidewalks that work wonderfully as S-curves or leading lines in photographs.

Because of the mild climate, flowers

Rod Barbee

Harris Beach State Park, sunset

Azalea Park, Brookings

bloom throughout the year, but the park's namesake, the azalea, will be in full bloom from late May through June. The annual Azalea Festival is held every Memorial Day weekend. Use everything from wide-angle lenses for landscapes to moderate telephotos to pick out details like the colorful bird houses to macro lenses for the flower blossoms.

Directions: Turn east off Highway 101 onto North Bank Road (north side of bridge), and turn left on Park Road. Azalea Park will be on your right just around a bend in the road.

Pelican Bay Lighthouse (143)

For you lighthouse collectors, this privately owned lighthouse, built in 1997 on a bluff overlooking Brookings Harbor, is the newest on the coast. Take Lower Harbor Drive past the harbor and shopping area to the Best Western. You'll see the lighthouse above you. A good spot to

photograph is from the Smuggler's Cove Restaurant across from the Best Western. Since you'll be looking up at this light, photographing on an overcast day will result in compositional disaster. Wait until you have a pretty sky behind the lighthouse.

Easter Lilies (144)

Ninety percent of the Easter lilies sold in America are grown in Brookings. In early summer fields of the lilies are in bloom between Brookings and Crescent City, California, along Highway 101.

You can also view the fields on Oceanview Drive. Go south on Highway 101 from the Chetco River Bridge, and turn right (west) onto Benham Lane. Shortly you'll see a sign to Oceanview Drive. Follow Oceanview for better views of the fields.

The Easter lily fields aren't set up for public visitation, so unless you can arrange special access, you'll be restricted to photographing from the side of the road. Do pictures of the entire scene, and save flower portraits for the gardens in Brookings.

Oregon Redwood Nature Trail (145)

Yes, redwoods do grow in Oregon! This short, pleasant trail leads to a nice grove of them. When you start out, you may wonder what the big deal is. Sure, there are some redwoods, but they're not *that* big. Just keep going. You'll come to a split in the trail. Go either way, and you'll soon come to a grove of good-sized trees.

They aren't as huge as the biggest trees in Redwood National Park, but they are pretty darn big. Some pretty darn big rhododendrons are here, as well, plus lots of ferns and wildflowers on the forest floor.

Directions: South of Brookings on Highway 101. Drive approximately 4 miles south of the Chetco River Bridge. Turn left (east) onto Winchuck River Road at the sign for the Oregon Redwood Trail. In about 1 mile turn right (following the sign), and drive a steep, narrow gravel road to its end at the trailhead. It actually takes longer to drive to the trailhead than it does to hike the trail.

Recommendations: You can go about photographing this part of the coast two ways. Drive along the coast and stop at every pullout, or go to one or two places, take a walk, and see what you can find. I prefer photographing a few areas well, as opposed to skimming the cream.

Whatever your approach, if you have bright, bad-photography light at midday, spend the time scouting new places or finding a good late-afternoon and sunset location. Nobody ever spends enough time scouting; they'd rather zoom around at the last minute to see what they can find. Give yourself a break, and your photography will improve.

Pro Tips: The question is always what to photograph in bad light. If by bad light you mean heavy overcast, I suggest going to a forest and using very long shutter speeds to take pictures. When the shutter is open for more than 30 seconds, the image you get will appear brighter than actual conditions. The trick is forcing yourself to take the picture despite what your brain is telling you.

If by bad light you mean bright-blue midday sky, go down to the rocky coast, and play with crashing waves against blue sky. Alternatively, go to a harbor and find lots of great reflections among the docks and fishing boats.

If by bad light you mean that you just don't feel like photographing anything (I get a lot of bad light like this), go for a long walk.

Cautions: Many of the best places to photograph are near cliffs, so be very careful when choosing your shooting site. And scout out your sunset locations earlier in the day so you'll be familiar with any hazards and won't have to stumble around looking for the best place to shoot.

Beware of possibly high winds and the sand and salt spray blown by it. Nothing can cause as much problems for your camera and lenses as salt water and sand. And as with the rest of the coast, be aware of the tides if you plan on photographing from the beach or walking around headlands.

All the trails are relatively easy, but keep in mind that the ones that lead down to beaches and other viewpoints mean hiking back up to get to your car. Hiking poles can be a godsend when you're hiking uphill with an extra 20 or 30 pounds of photo gear on your back.

Many pullouts are very popular tourist stops, which means they're also very popular stops for thieves. Be sure to lock your car (and set your alarm if you have one), and cover up any valuables left behind.

Distractions: The Rogue River drains most of the southern part of the Coast Range. Because the river is so beautiful and remains so wild, it's a well-known draw for fishermen and pleasure seekers alike. The best way to see the river is via jet boat. A jet boat is more carnival ride than practical means of getting somewhere, but it's a blast, and you'll see some very remote country. You won't be able to photograph from the jet boat, so leave your camera behind, and go have some fun.

VIII. Favorites

Favorite Harbors

1. Charleston
2. Newport
3. Port Orford
4. Depoe Bay
5. Astoria
6. Florence
7. Tillamook

Favorite Towns

1. Yachats
2. Astoria
3. Old Town Florence
4. Depoe Bay
5. Bandon
6. Newport
7. Gold Beach
8. Waldport

Favorite State Parks (camping)

1. Cape Blanco
2. Sunset Bay
3. Jesse Honeyman
4. Fort Stevens
5. Cape Lookout
6. Shore Acres

Favorite State Parks (photo)

1. Boardman
2. Shore Acres
3. Harris Beach
4. Cape Blanco
5. Ecola
6. Cape Kiwanda
7. Cape Perpetua
8. Seal Rock

Fishing nets

Favorite Lighthouses

1. Heceta Head from Highway 101 viewpoint
2. Heceta Head from behind lighthouse
3. Cape Blanco
4. Cape Arago
5. Yaquina Head from state park
6. Yaquina Head from Moolock Beach
7. Cape Meares
8. Yaquina Bay

Favorite Crashing Waves

1. Shore Acres
2. Yachats
3. Boiler Bay
4. Cape Kiwanda
5. Otter Point
6. Cape Arago

Favorite Sunset Locations

1. Bandon Beach
2. Oceanside
3. Ecola State Park

4. Harris Beach State Park
5. Cape Lookout Beach
6. Redfish Rocks
7. Blacklock Point
8. Astoria Bridge
9. Cape Falcon viewpoint

Favorite Sunrise Locations

1. Bandon Beach
2. Yaquina Bay Bridge Park
3. Astoria Column
4. Newport Harbor (if foggy)
5. Charleston Harbor (if foggy)
6. Cape Blanco Light
7. Yaquina Head Light
8. Boiler Bay

Favorite Beaches

1. Bandon
2. South Beach
3. Hug Point

Sunset, Cape Lookout State Park

4. Meyers Beach, Pistol River
5. Oceanside
6. Cape Blanco
7. Harris Beach
8. Pistol River

Favorite Tide Pools

1. Cape Perpetua
2. Seal Rocks
3. Harris Beach
4. Cape Sebastian

Favorite Hikes

1. Cape Lookout
2. Sweet Creek
3. Shrader Old Growth
4. Blacklock Point
5. Shore Acres
6. Cascade Head

Prettiest Roads

1. Boardman State Park
2. Pistol River State Park
3. Oswald West State Park
4. Humbug Mountain to Cape Blanco
5. Cape Arago Highway
6. Three Capes Loop
7. Beach Loop Drive, Bandon
8. Otter Loop Road

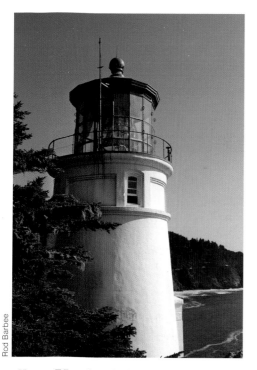

Heceta Head Light from behind lighthouse

Rod Barbee

Three Arch Rocks at sunset

Most Published Images

1. Heceta Head Light
2. Haystack Rock at Cannon Beach
3. Yaquina Head Light
4. Bandon Beach
5. Astoria Bridge
6. Crescent Beach from Ecola State Park
7. Newport Bridge

Our Personal Favorites

1. Sweet Creek
2. Shore Acres
3. Charleston Harbor
4. Bandon Beach
5. Columbia Maritime Museum
6. Oregon Coast Aquarium, Newport
7. Charleston Harbor
8. Oceanside, Three Arch Rocks
9. Cape Kiwanda
10. Yaquina Bay Bridge, Newport

Favorite Nonphotography Places

1. Columbia Maritime Museum
2. Tillamook Cheese Factory
3. Sea Lion Caves
4. Seaside Outlet Mall
5. Any chamber of commerce
6. Shore Acres gift store
7. Fred Meyer stores
8. Mo's Restaurants, all along the coast
9. Canyon Way Restaurant, Newport

David Middleton

Harborman's gear, Charleston Harbor